I AM A GREAT SINKING

MEMORY
WILL FAIL YOU

SHIP OF

HOME IS WHERE THE
HEART ACHES

YOU'RE DROWNING IN ENNUI

THERE'S A PATTERN TO YOUR BULLSHIT

VACATION WON'T SAVE
YOUR RELATIONSHIP

TEETH FALL OUT

EVERYTHING IS

SELF-SABOTAGE

NOTHING
NEVER
NO ONE

BIRTHDAYS
DON'T MATTER

YOU'RE TEMPORARY

I AM LOST IN A
WILDERNESS
OF GRIEF

ALL HEARTS COLLAPSE

I AM TETHERED TO THE
GHOSTS OF MY PAST

I AM NO
SUCCESS

THE ABYSS
STARES
RIGHT BACK

I AM ETERNALLY A
FLIGHTLESS BIRD

EVERY LOVE FALLS APART

NO ONE
IS PROUD OF YOU

YOU'RE DOOMED

ONLY YOU RUIN YOUR LIFE

I DON'T REALLY LOVE YOU

Running Press
Hachette Book Group
1290 Avenue of the Americas
New York, NY 10104
www.runningpress.com
@Running_Press

Printed in China

First Edition: October 2018

Published by Running Press, an imprint of Perseus Books, LLC, a subsidiary of Hachette Book Group, Inc. The Running Press name and logo is a trademark of the Hachette Book Group.

The Hachette Speakers Bureau provides a wide range of authors for speaking events. To find out more, go to www.hachettespeakersbureau.com or call (866) 376-6591.

The publisher is not responsible for websites (or their content) that are not owned by the publisher.

Design by Joshua McDonnell and Christopher Eads.

Library of Congress Control Number: 2018943837

ISBNs: 978-0-7624-6536-1 (hardcover), 978-0-7624-6537-8 (e-book)

1010

10 9 8 7 6 5 4 3 2 1

I DON'T REALLY LOVE YOU

And Other Gentle Reminders

of Existential Dread in Your Everyday Life

ALEX BEYER

RUNNING PRESS

PHILADELPHIA

AN INTRODUCTION

Now, if I were to start things off the way I really wanted to, this introduction would go something like this:

In the solemn bleariness of morning, I often watch the sun trying to touch the city, following my train, and me with it. Some days I wonder if today is the day, if I were to initiate the count, that its light would finally cease in the five hundred seconds it takes me to travel through space. Then I wait, in eight minutes of moribund expectation.

However, if I did that you'd stop reading, and doubt if I actually had any friends.

So let's change the subject to something more comforting: Existential Dread. Some people think that's about dark truths. Others might call existential dread a pretentious attitude that attacks the absurdity of the world. I have always chosen to bring dread back to its primary tenet: authenticity.

Admit it. It's easy to go weeks and years in the routine of our lives, orbiting each other but never moving anywhere. Then the night comes and you can't sleep and the world shakes at the importance of its own acknowledgment: You Will Not Live Forever.

You know, fun stuff like that.

Against this backdrop, it is perhaps only natural that my preferred art seems to be the kind that most leaves the spectator with a sense of confused emotion. An upbeat, jangling song, punctuated by desolate, venomous lyrics. A finely painted masterwork about the end of the world. That dichotomy—that's where I choose to live.

And it is the foundation for my project, *365 Days of Dread*, as well as the book before you now.

Over the past few years, I have taken photos of animals and pets from around my life and received a number of submissions from others in my city of Philadelphia. Using these images, I have been able to slowly grow and refine *365 Days of Dread* in its online form as the *Existential Pets* series.

What a long way to say that I like sad stuff.

That's why I started this project. *The Existential Pets* touches on this aspect of uncomfortable and unclear emotion. It also examines and remarks on all media, whether it is social, published, or otherwise. From selfies to baby photos to the obsession with pictures of our pets, I want this project to serve as a reminder of an element of dread that still exists within the everyday, as we feel both closer to and farther away from one another in the digital age. We are obsessed with constant content to feel fulfilled. I think it's important to remind everyone that all human history will one day be burned away by a dying sun.

Also, pets. Come on—they are the absurdly perfect foil for the melancholic realizations we suffer in the modern era. But I've always wanted this project to have a tangible form—one that can be gifted and shared in a new way. And this is just that.

So here it is: my anti-devotional, my daily un-devotional. Call it whatever you'd like. Just choose to either accept or deny the ephemeral nature of all things, because in the end we're still spinning through space. Laugh, but don't forget.

ALEX BEYER
PHILADELPHIA, PA

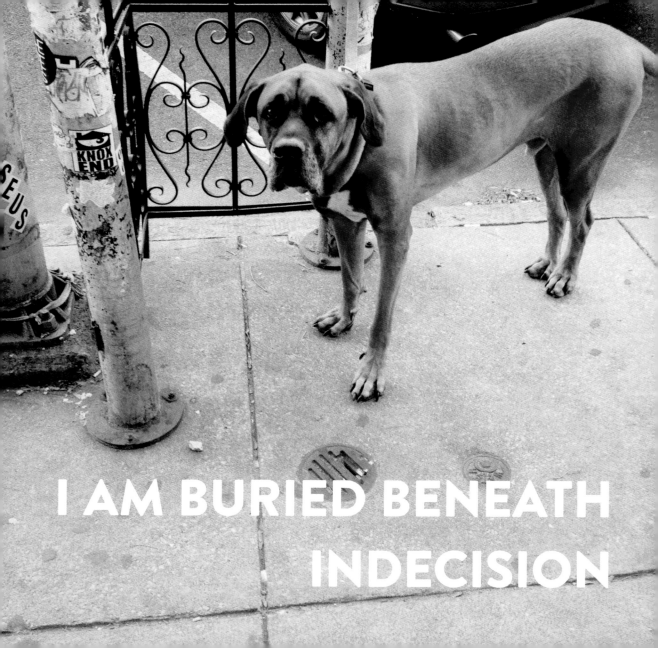

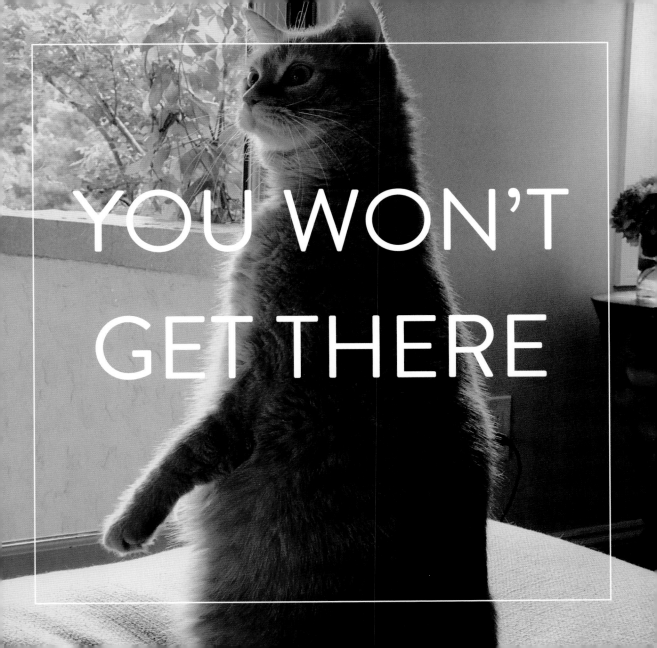

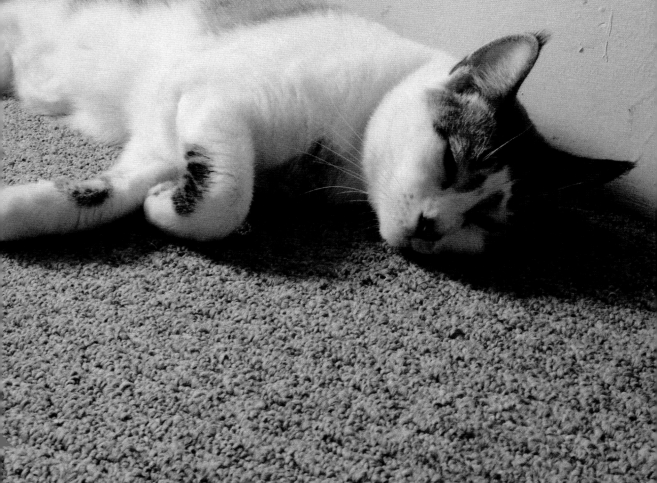

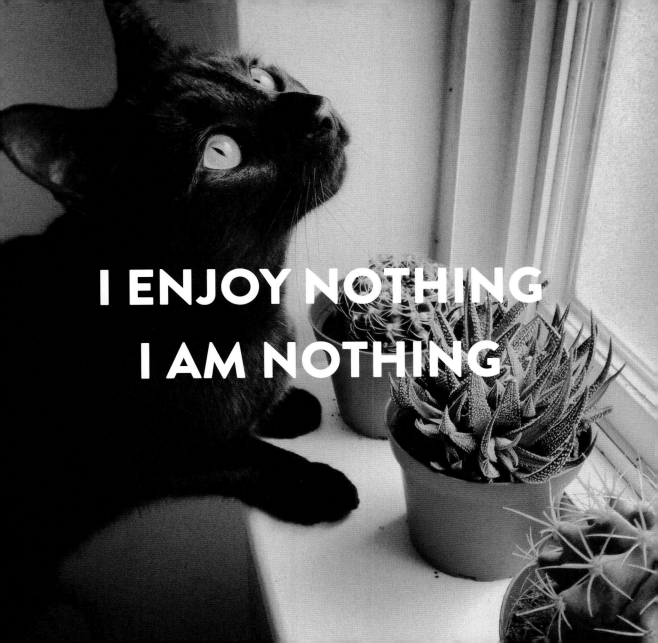

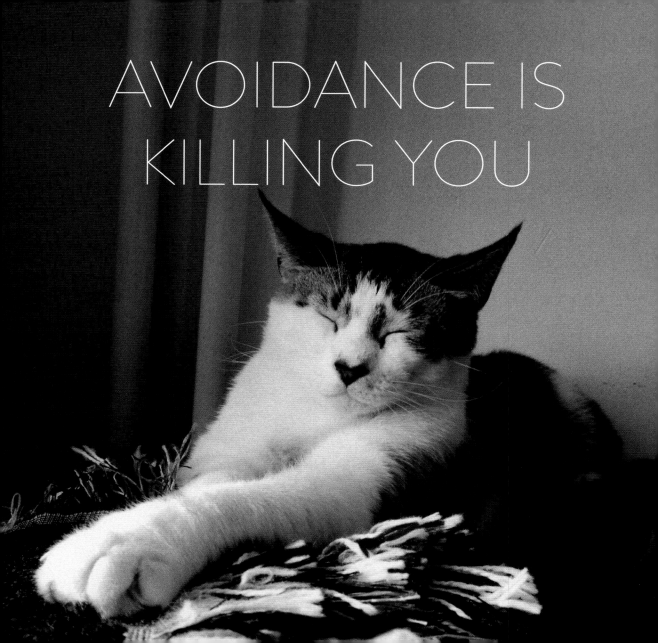

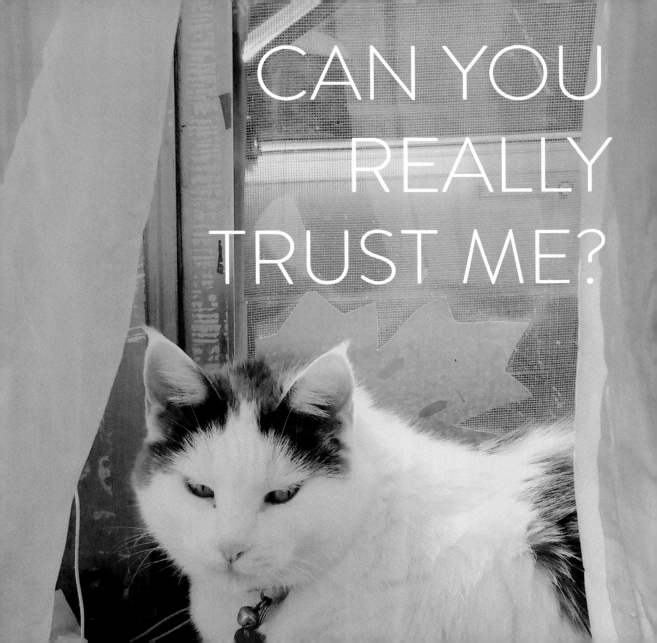

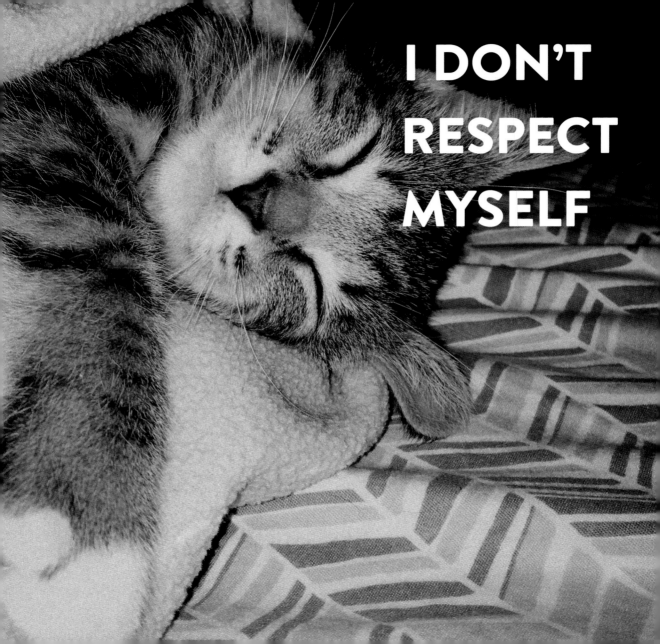

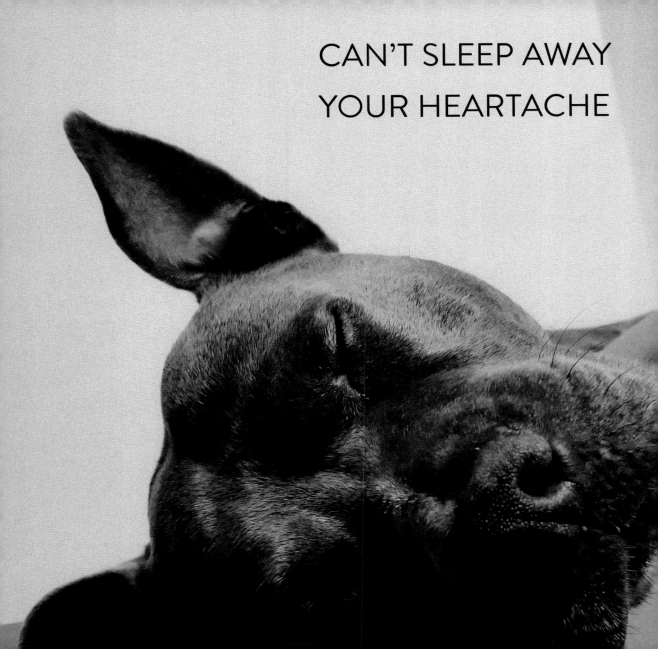

CAN'T SLEEP AWAY
YOUR HEARTACHE

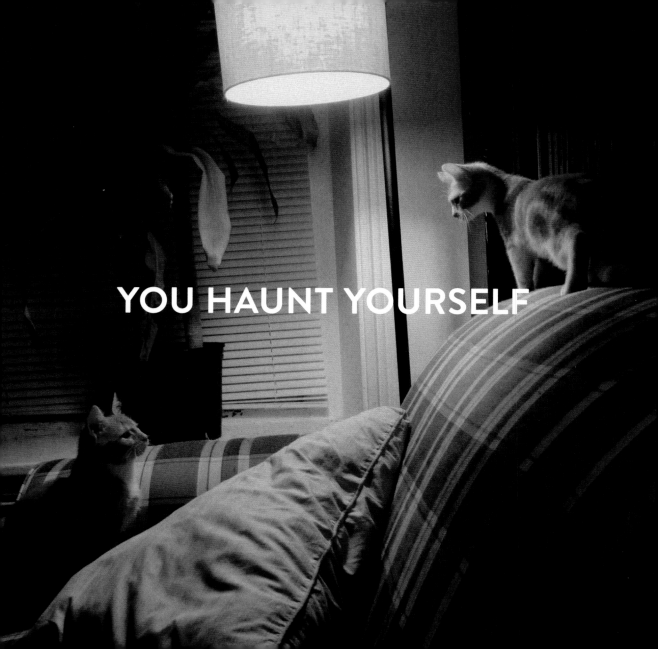

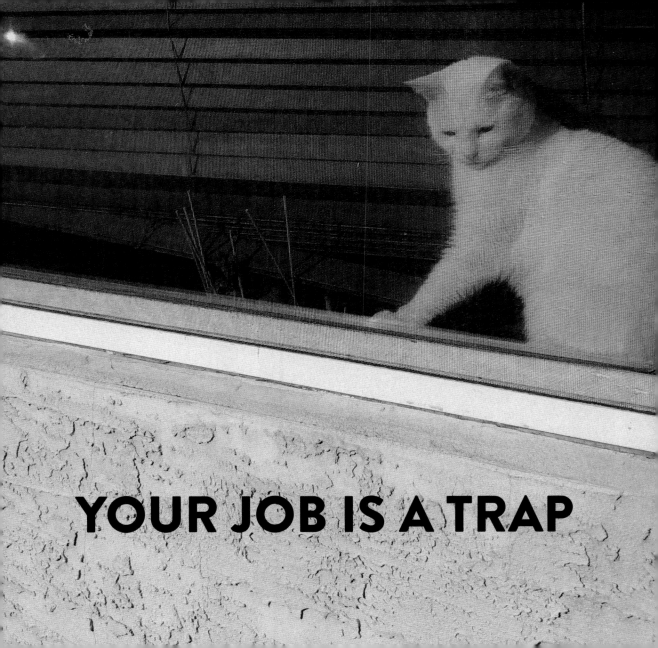

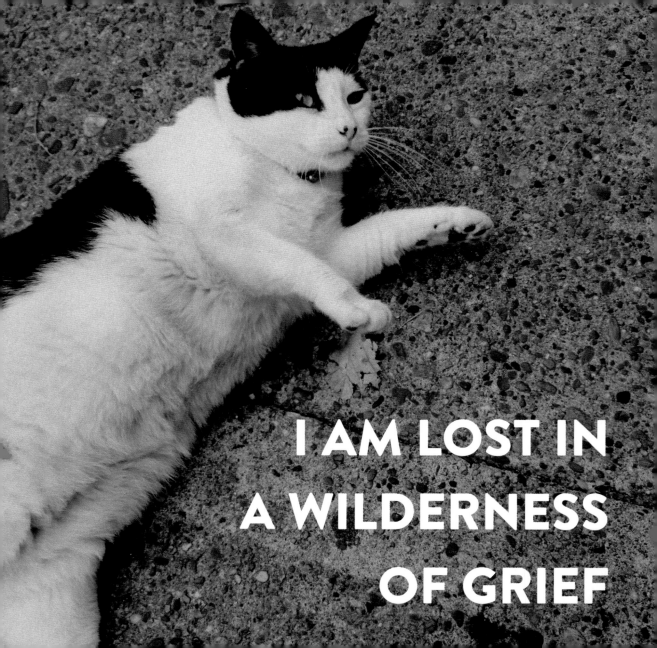

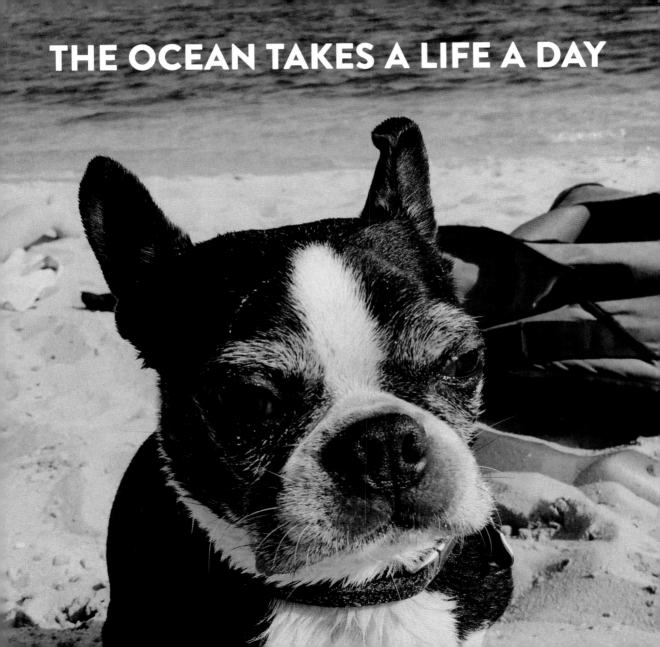

THE OCEAN TAKES A LIFE A DAY

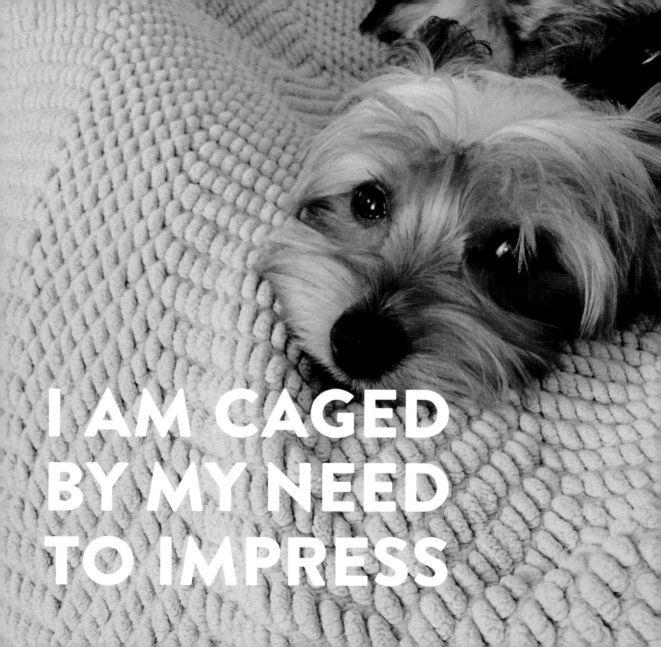

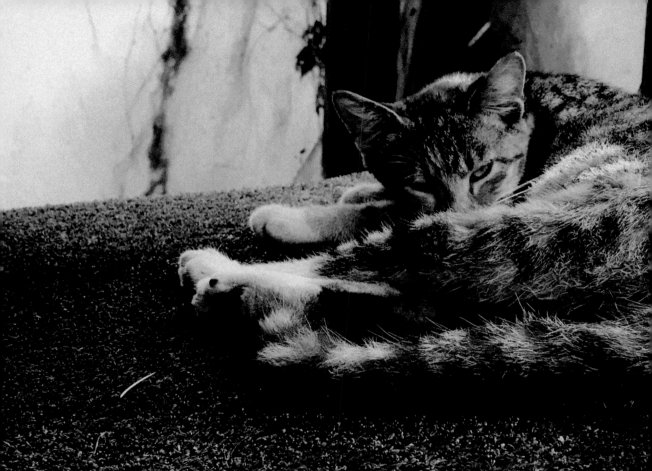

LET ME DISAPPEAR

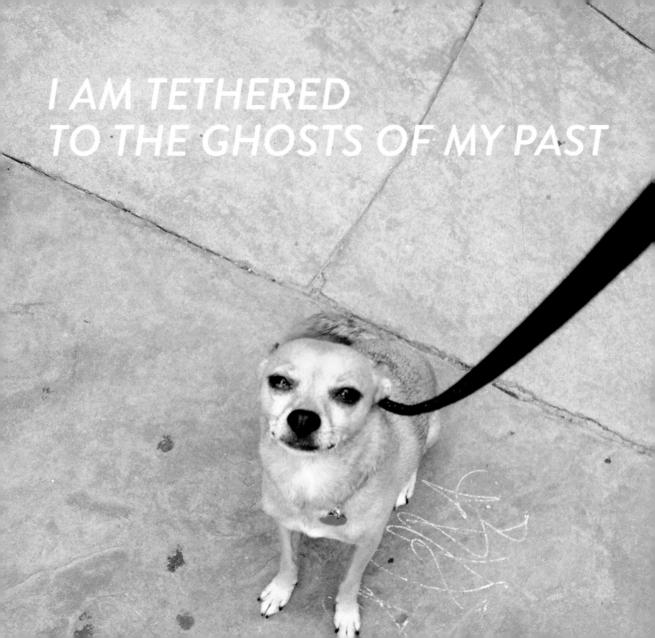

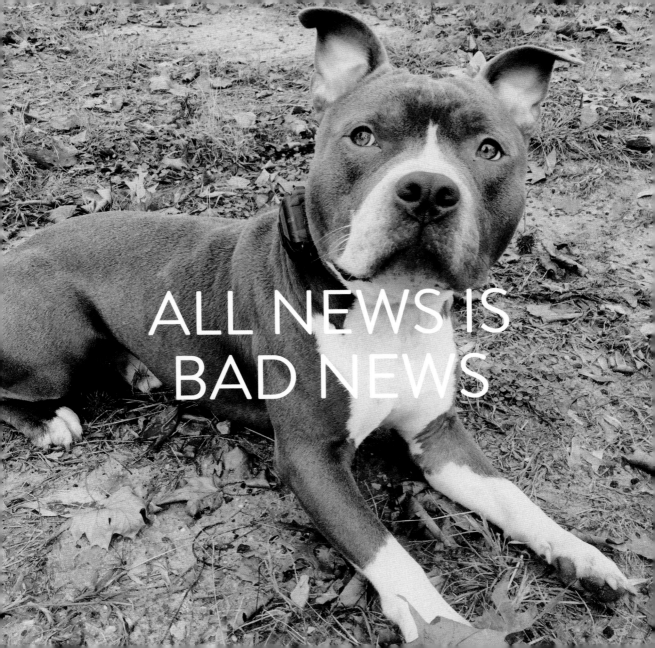

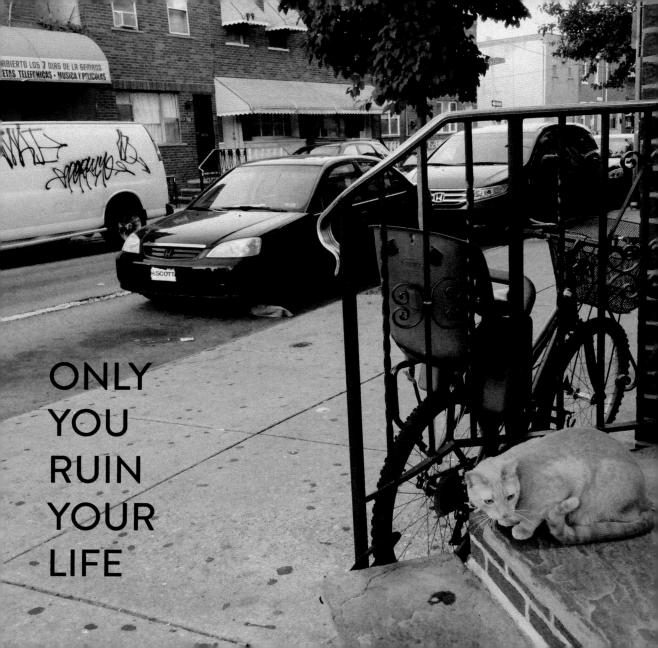

ONLY
YOU
RUIN
YOUR
LIFE

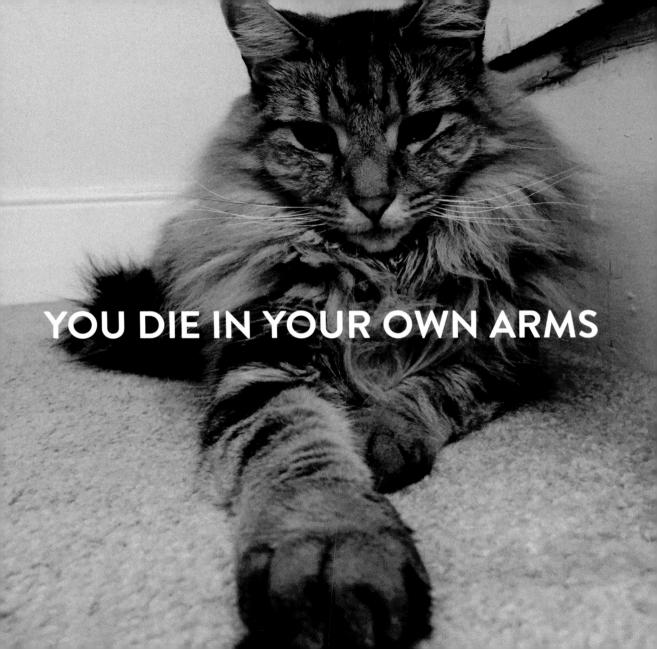

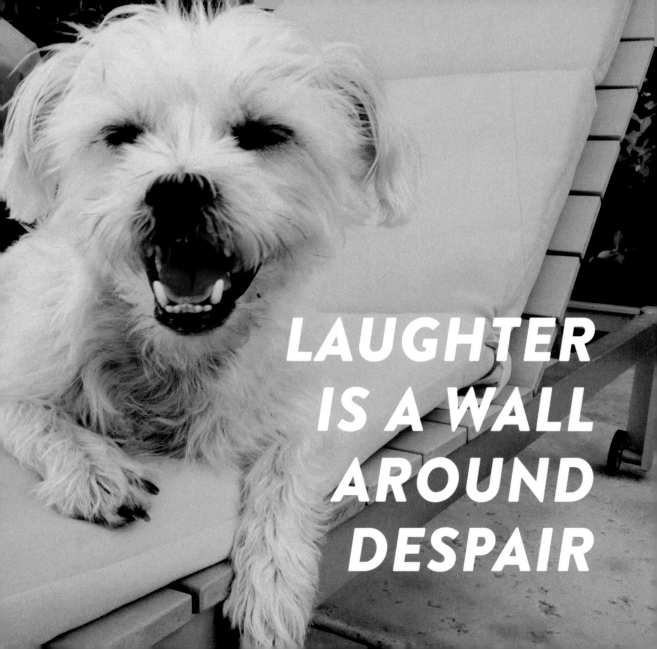

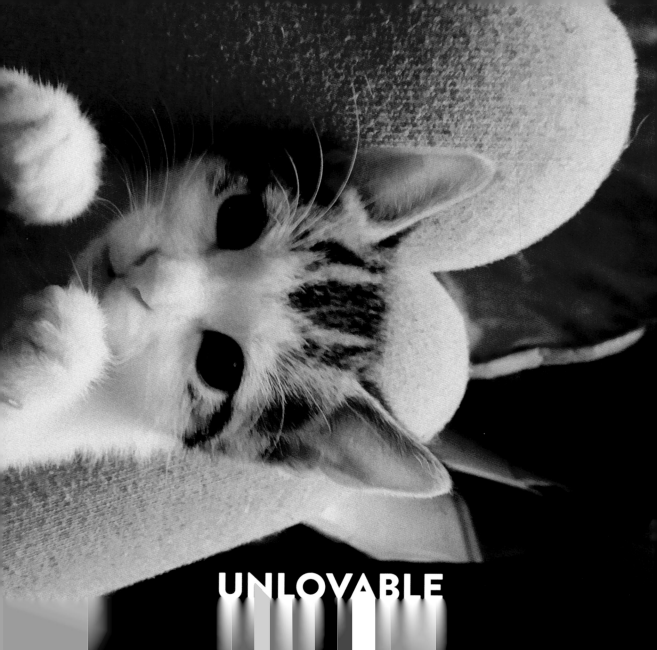

YOU'RE UGLY

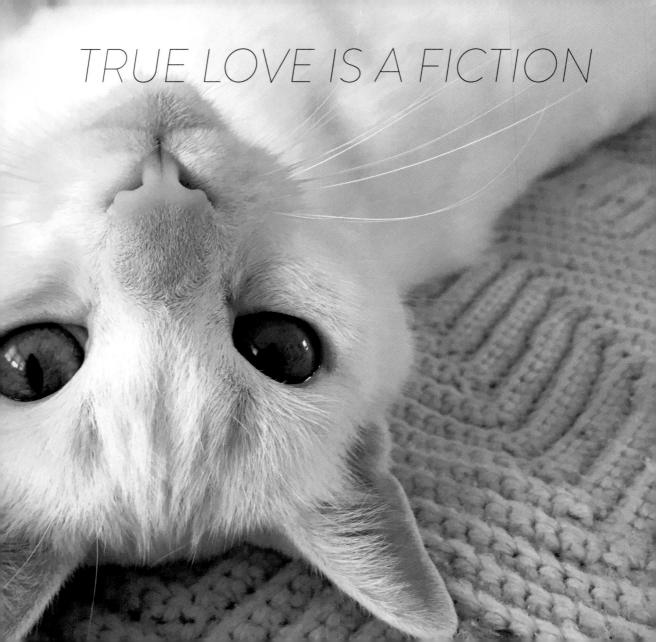

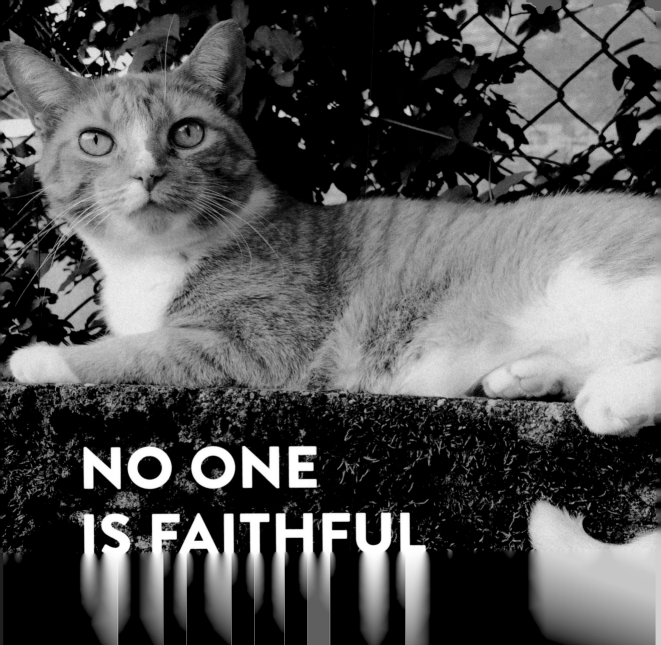

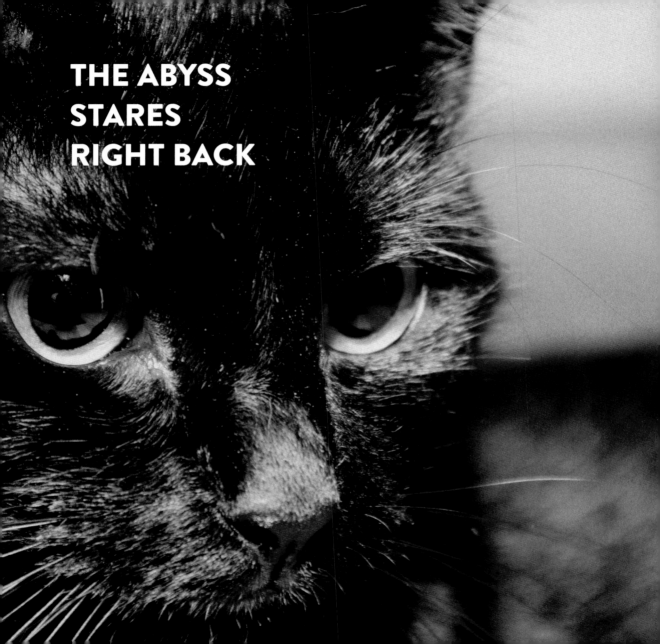

THE ABYSS
STARES
RIGHT BACK

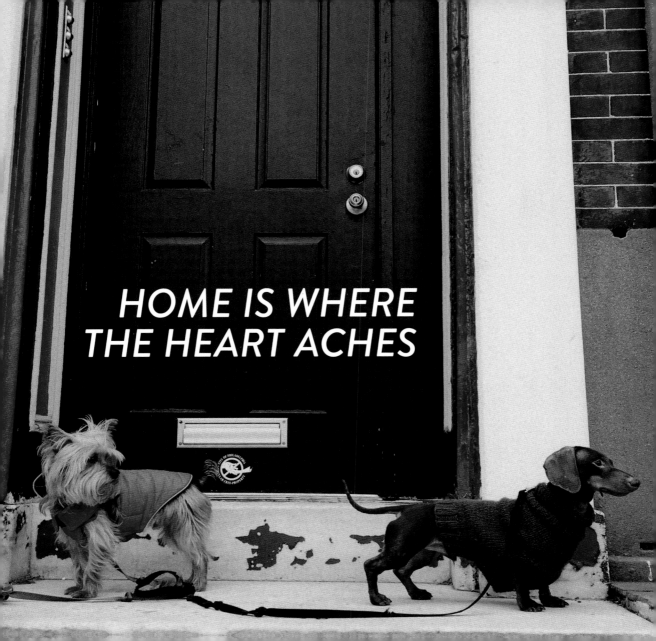

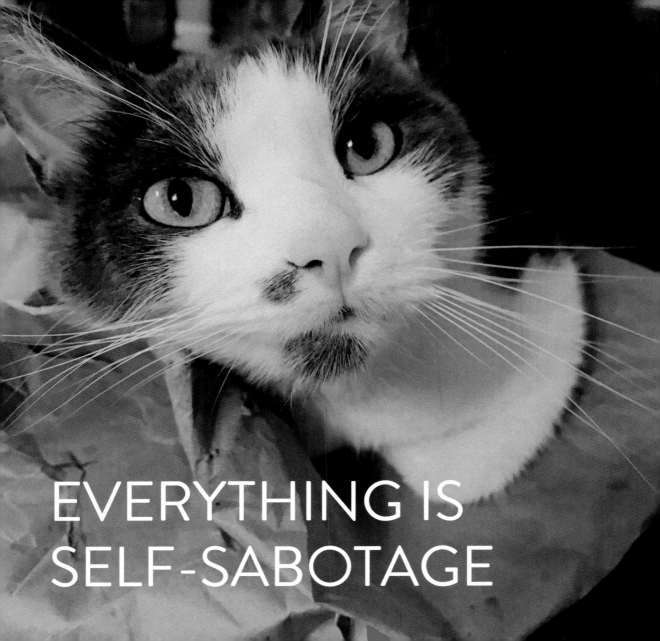

EVERYTHING IS
SELF-SABOTAGE

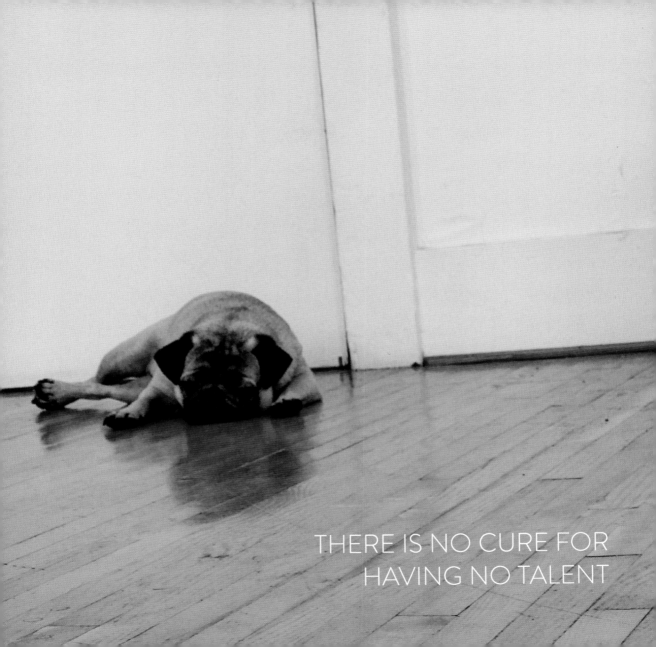

THERE IS NO CURE FOR
HAVING NO TALENT

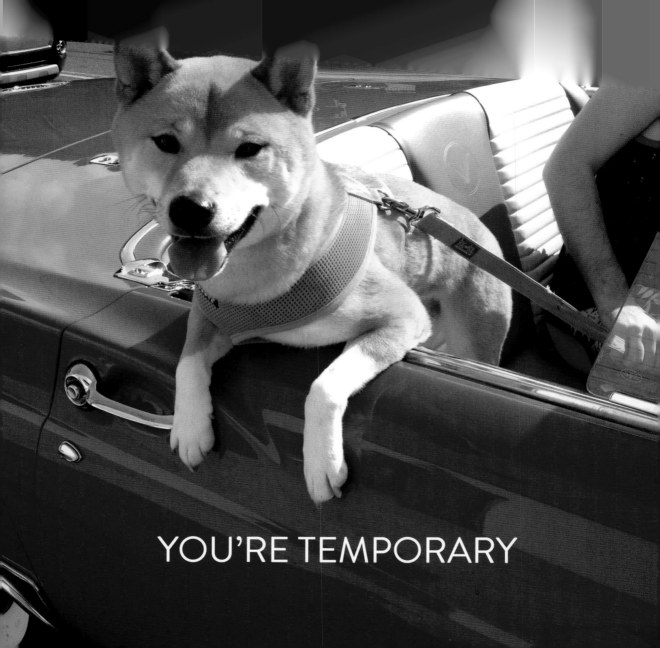

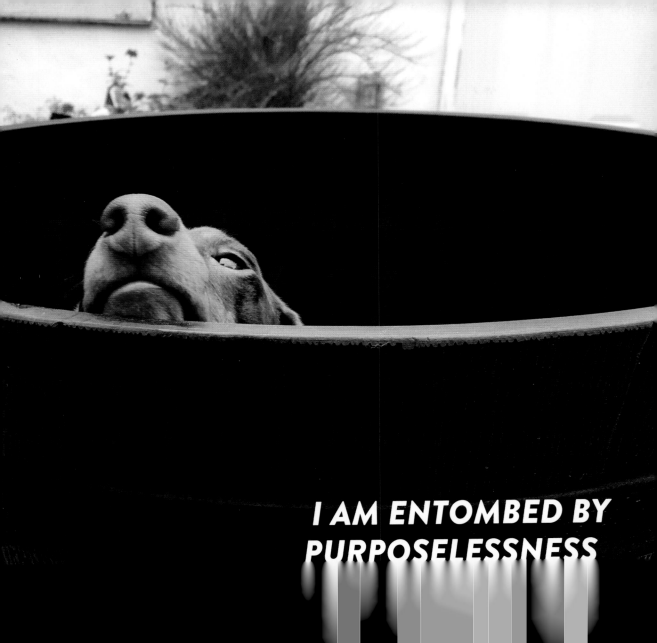

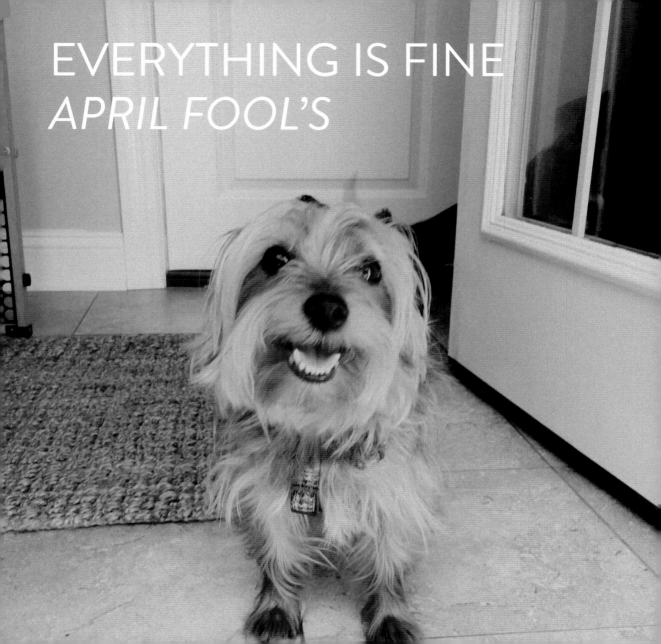

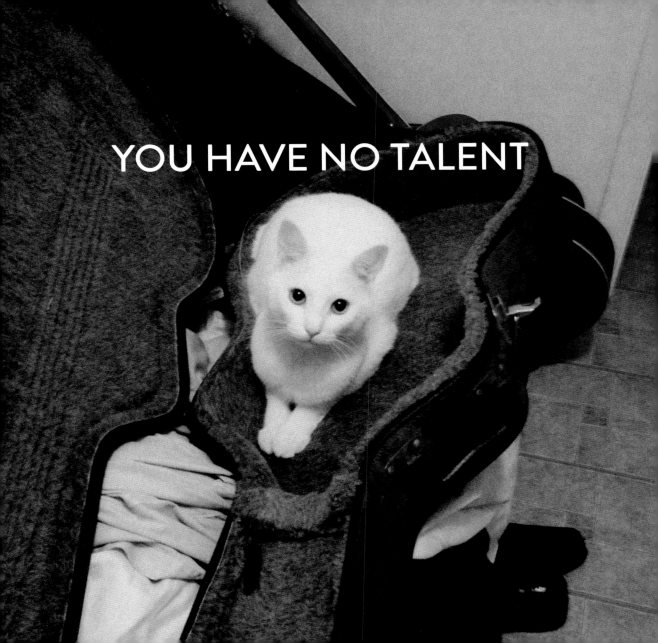

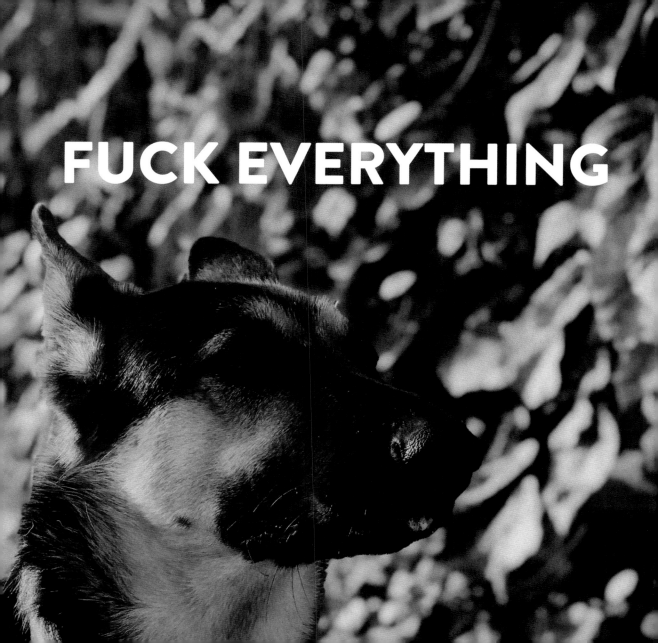

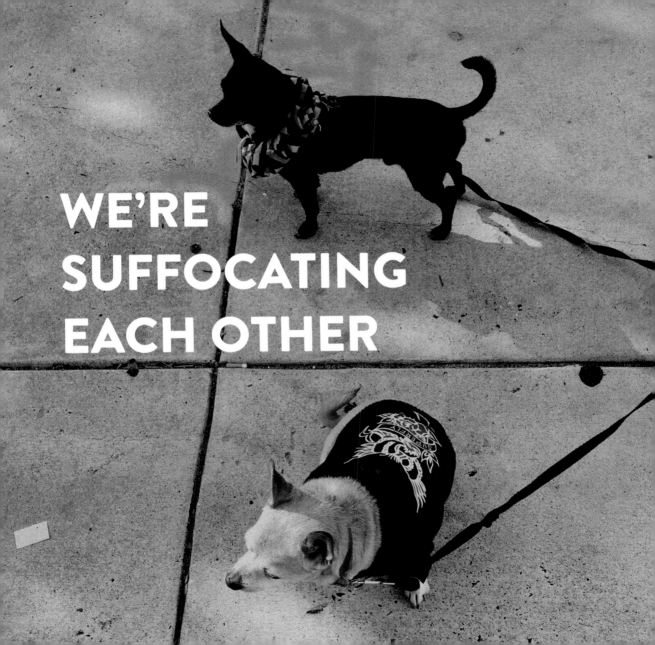

VACATION WON'T SAVE YOUR RELATIONSHIP

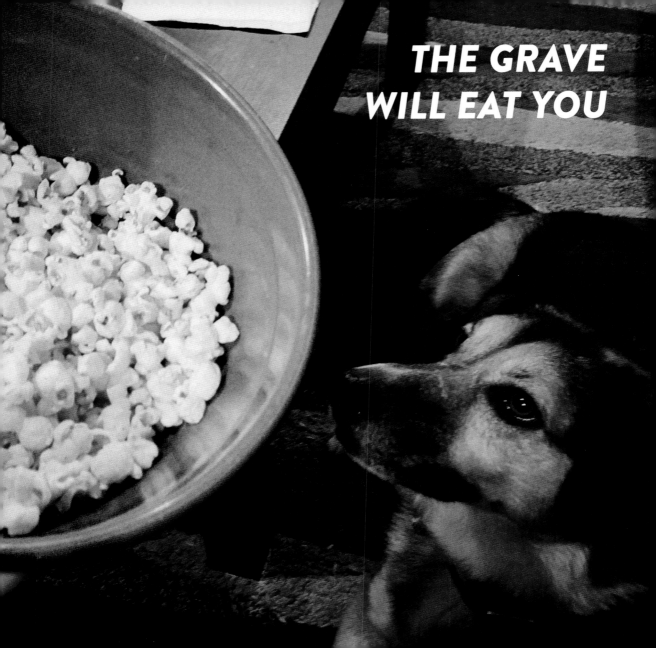

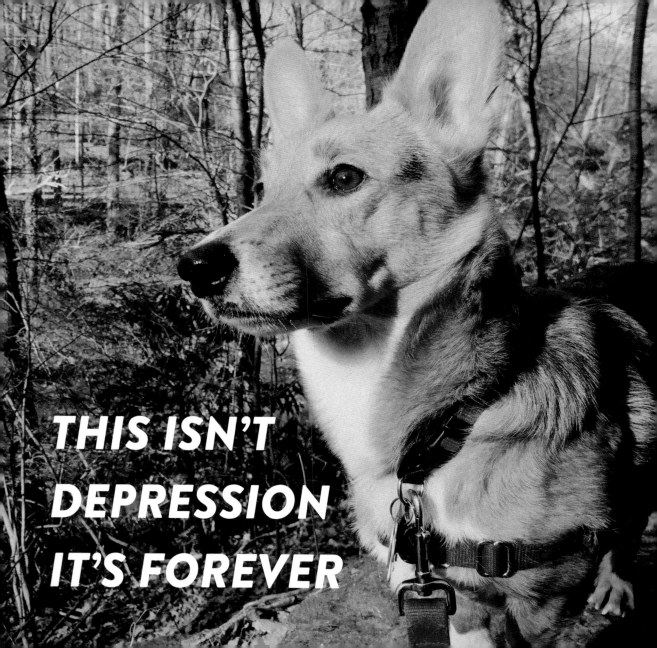

THIS ISN'T DEPRESSION IT'S FOREVER

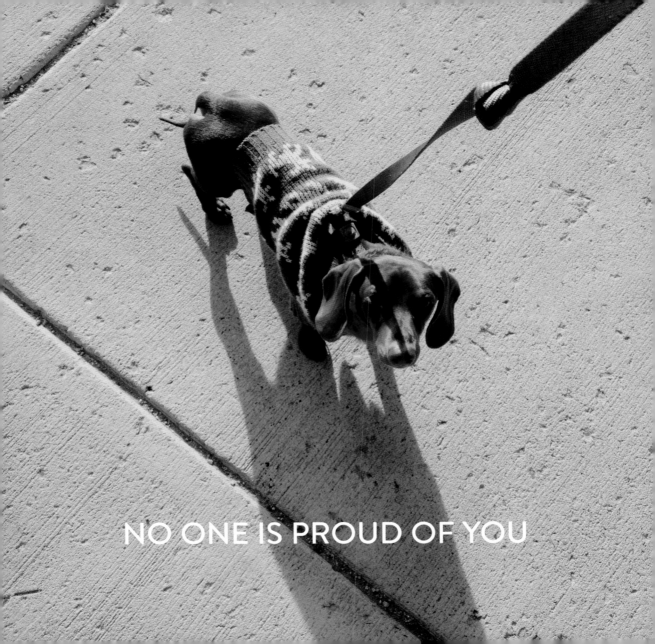

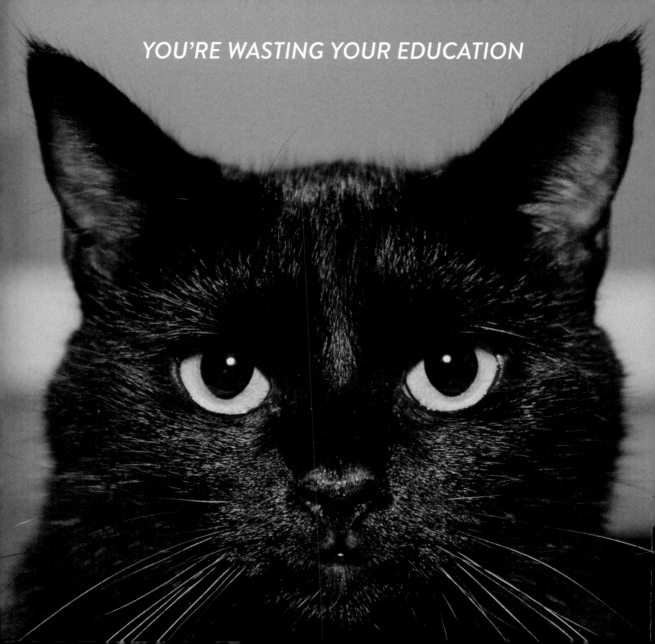

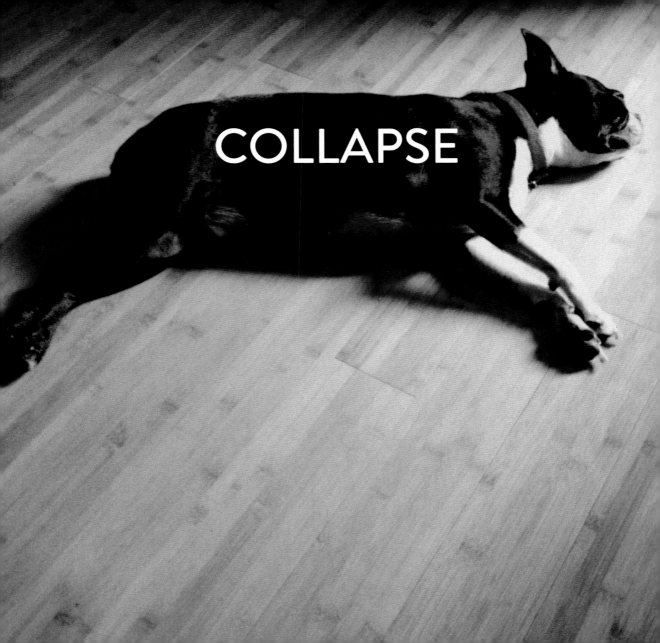

COLLAPSE

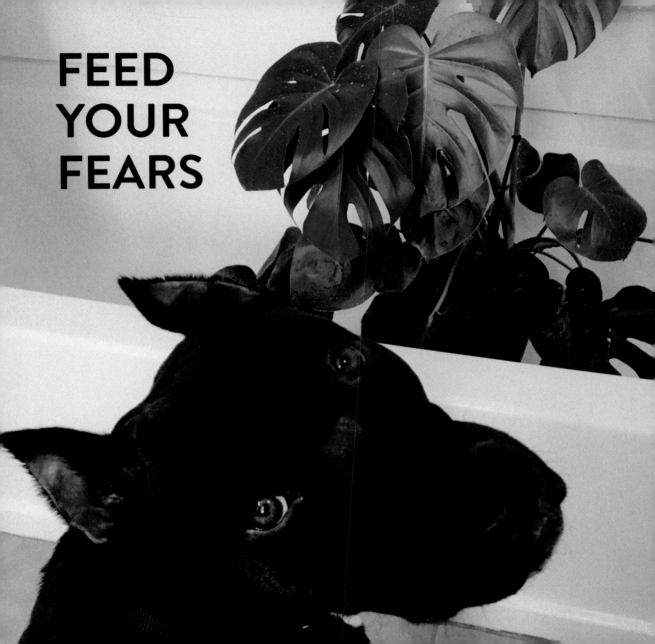

FEED
YOUR
FEARS

BIRTHDAYS DON'T MATTER

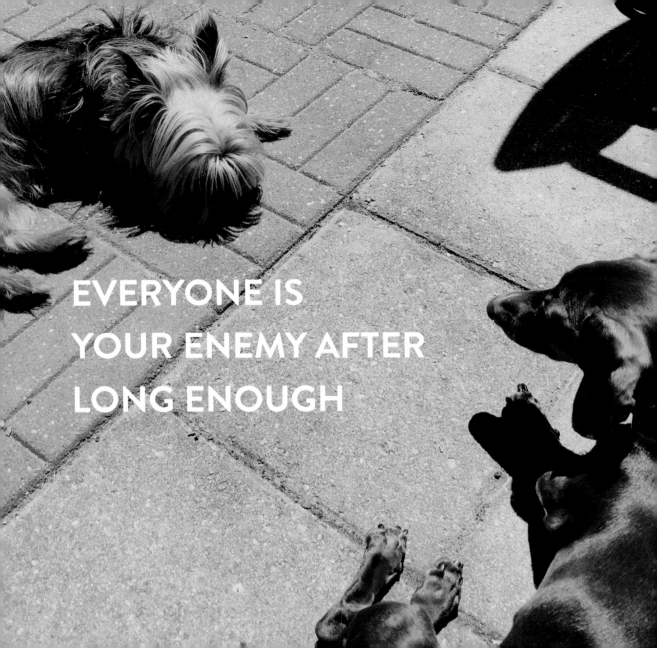

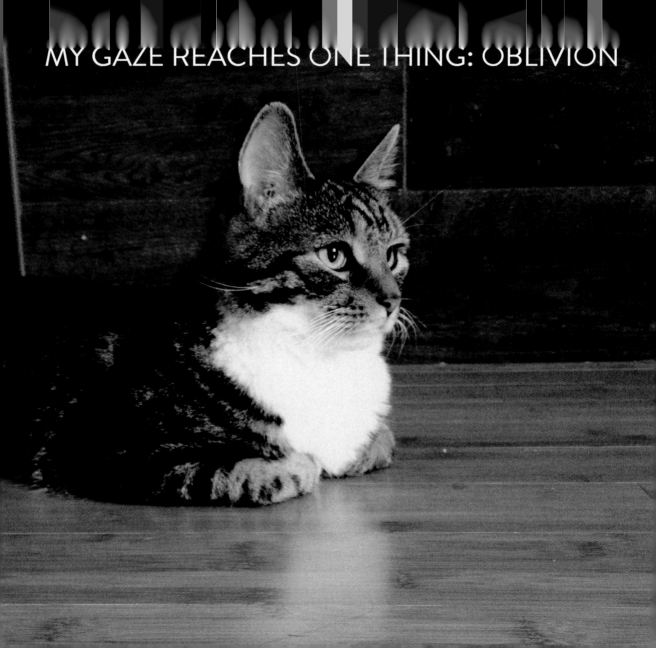

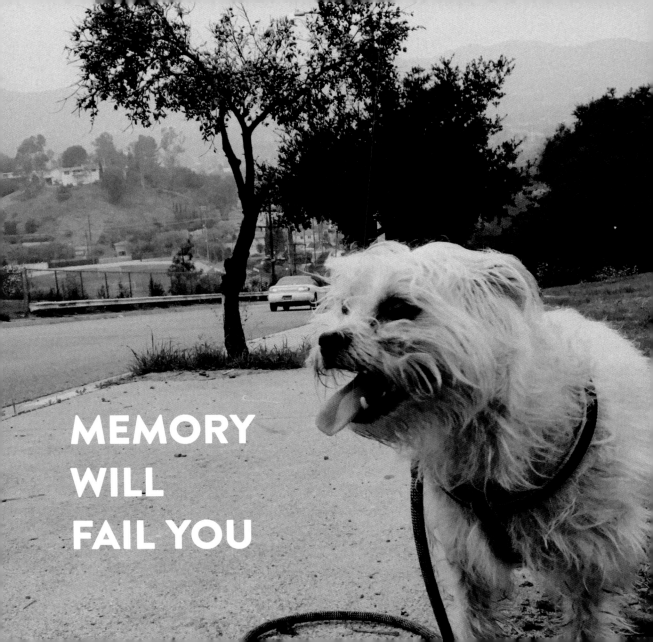

MEMORY
WILL
FAIL YOU

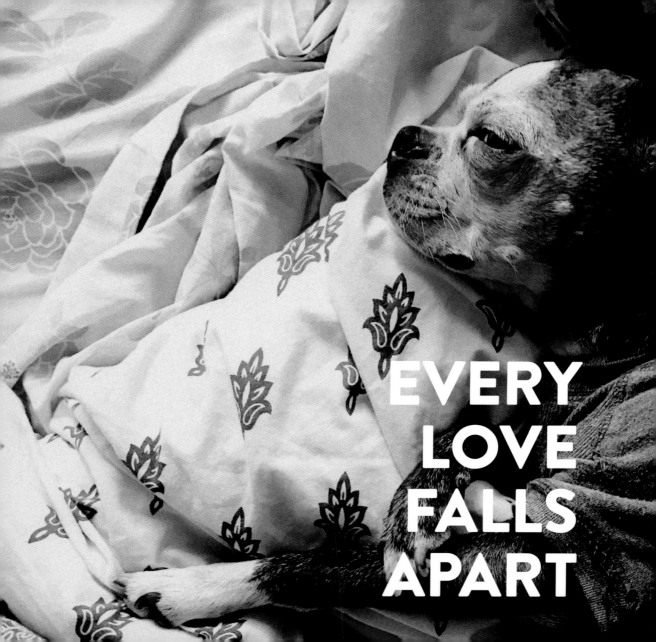

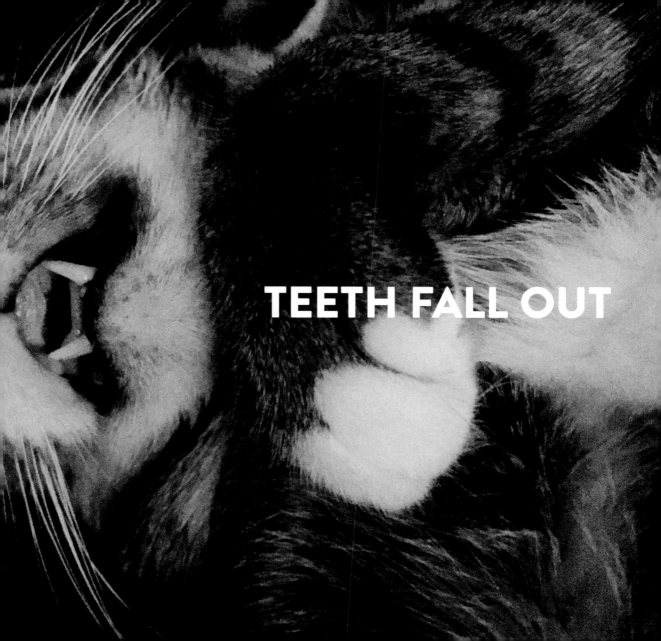

TEETH FALL OUT

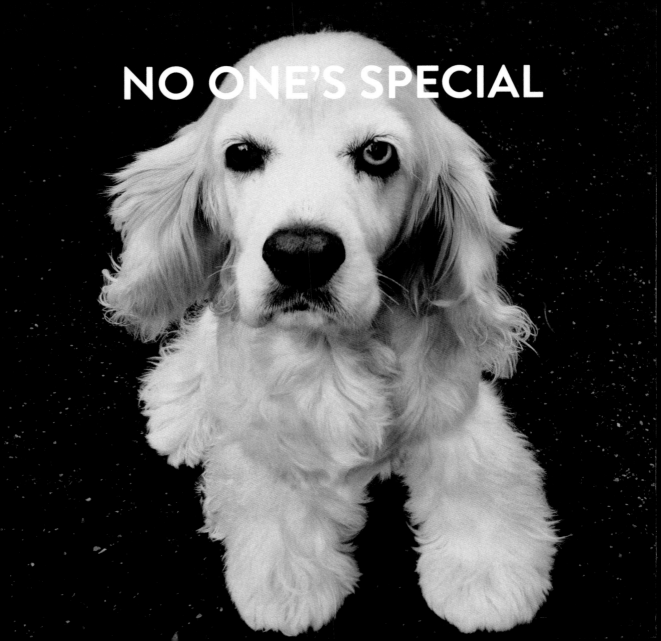

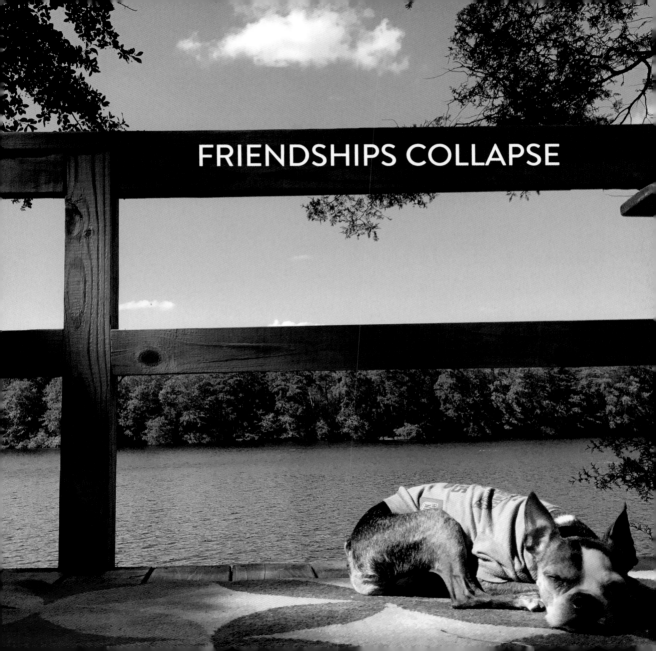

FRIENDSHIPS COLLAPSE

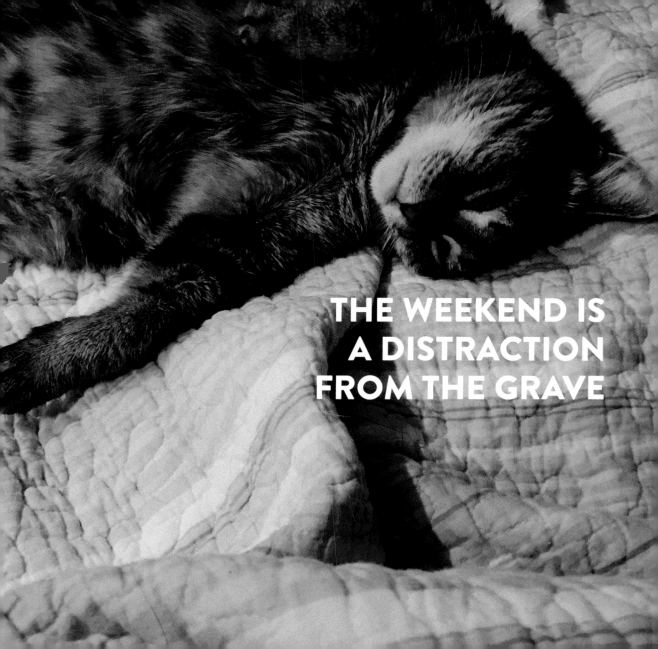

THE WEEKEND IS
A DISTRACTION
FROM THE GRAVE

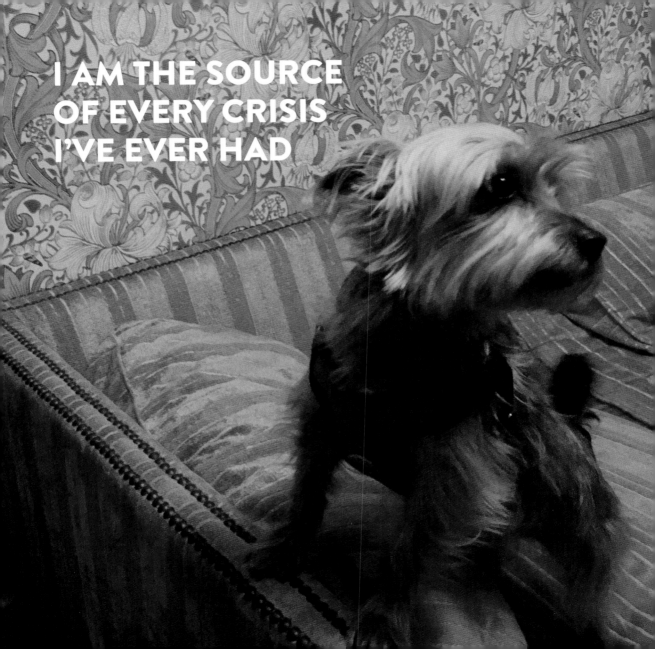

I AM THE SOURCE
OF EVERY CRISIS
I'VE EVER HAD

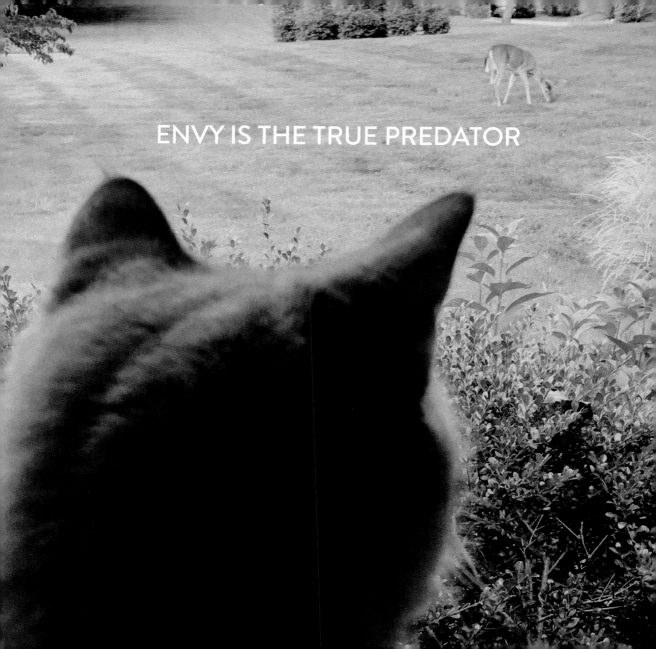

ENVY IS THE TRUE PREDATOR

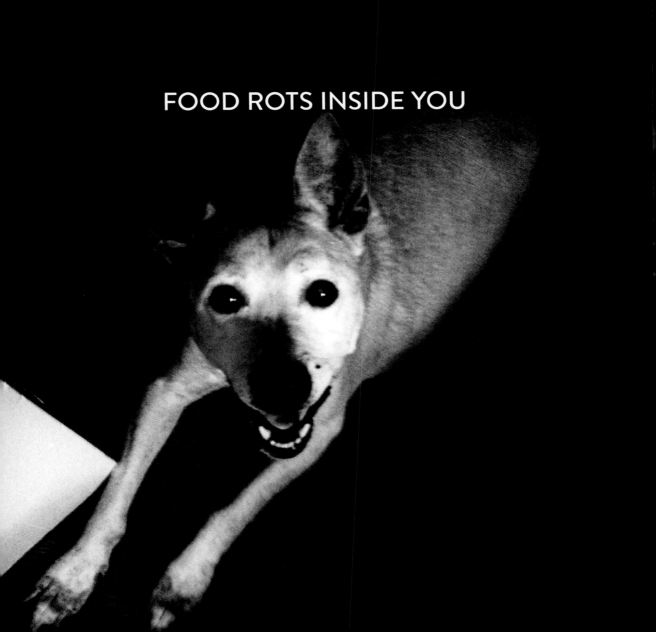

FOOD ROTS INSIDE YOU

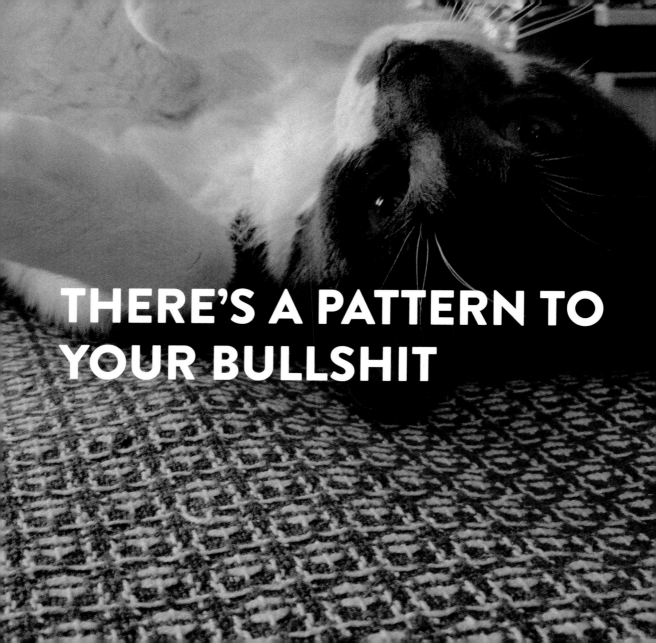

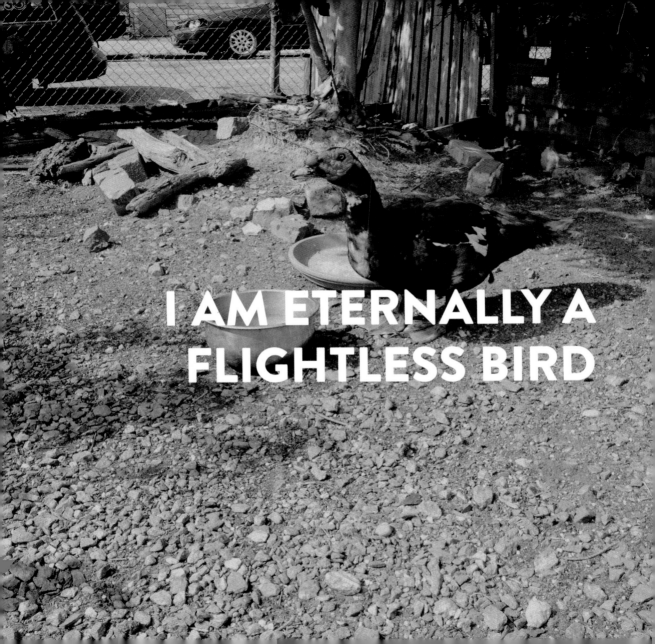

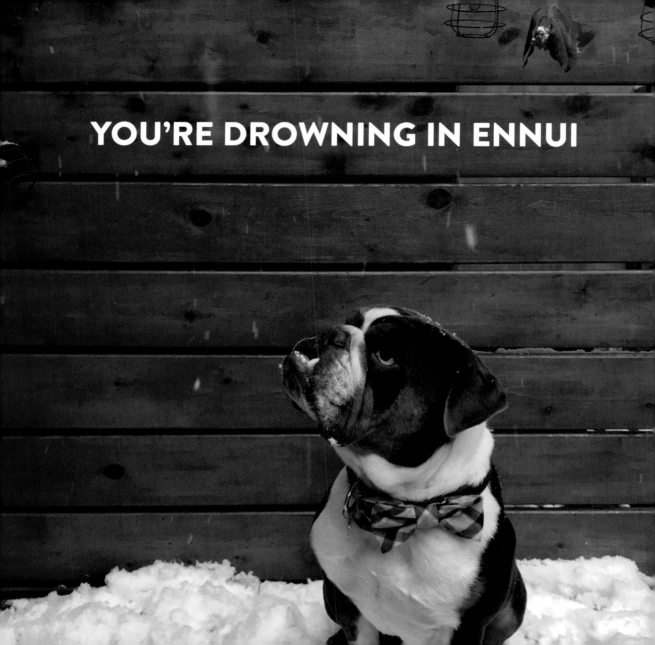

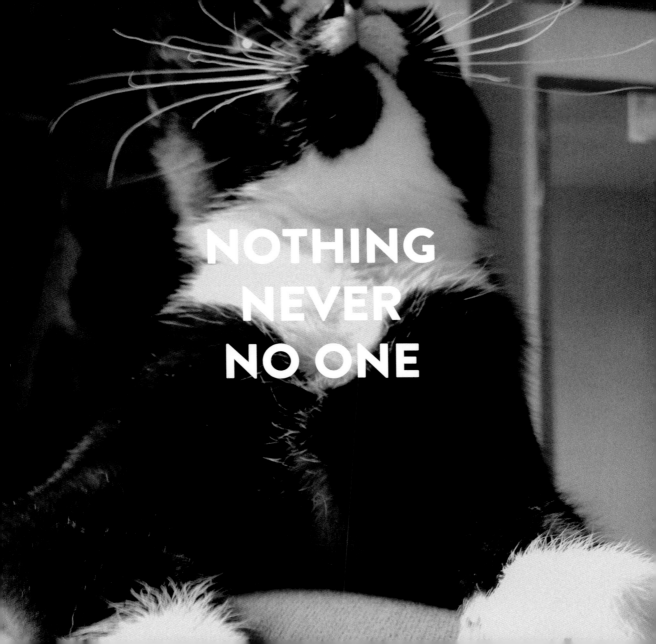

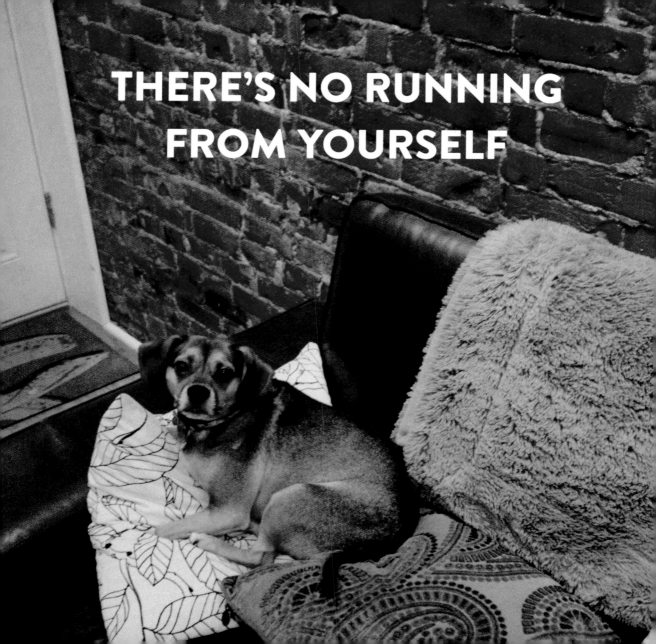

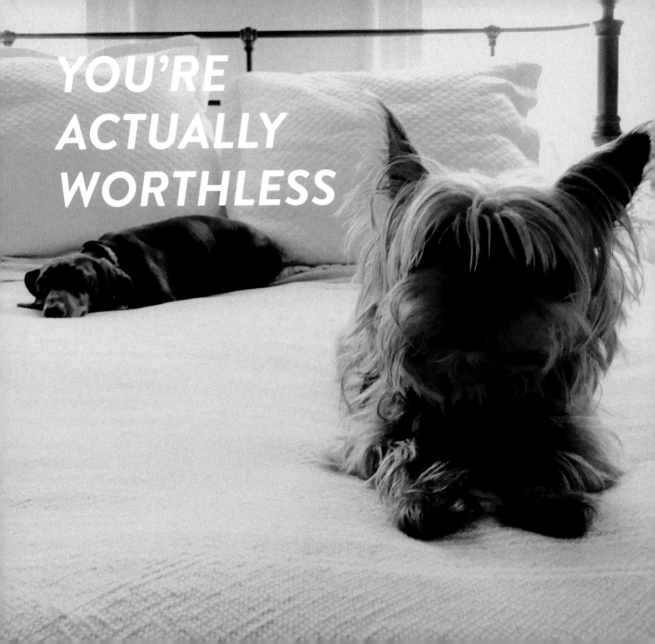

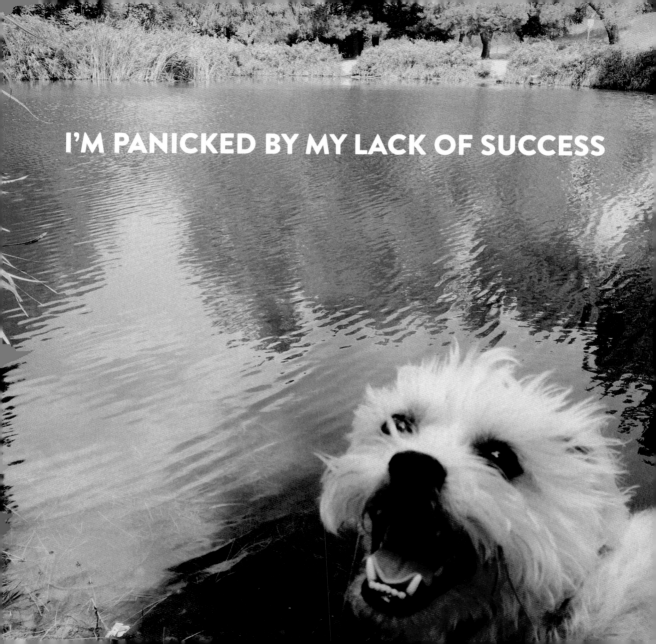

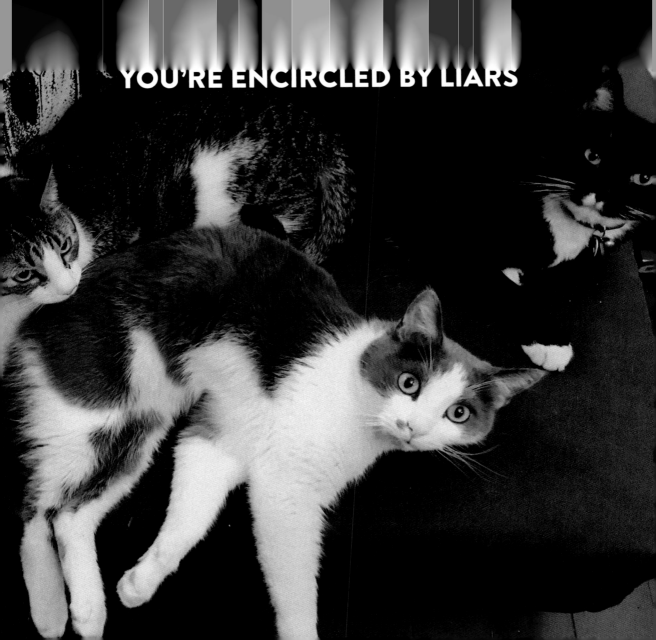

YOU'RE ENCIRCLED BY LIARS

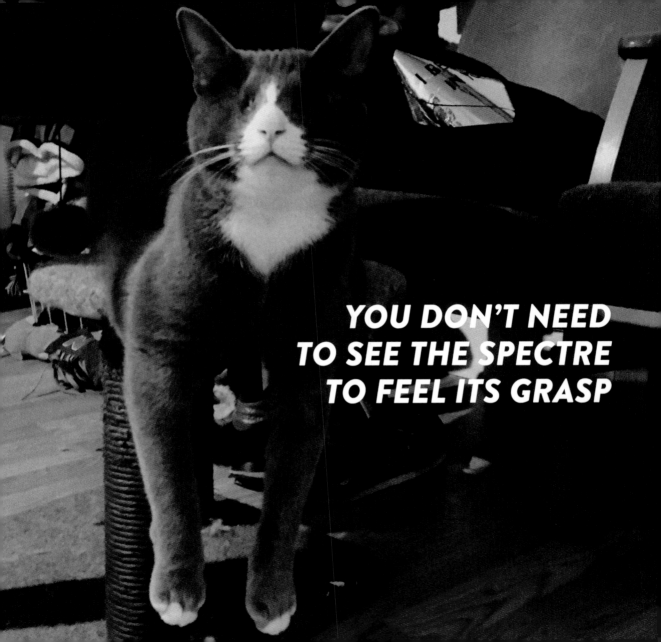

YOU DON'T NEED
TO SEE THE SPECTRE
TO FEEL ITS GRASP

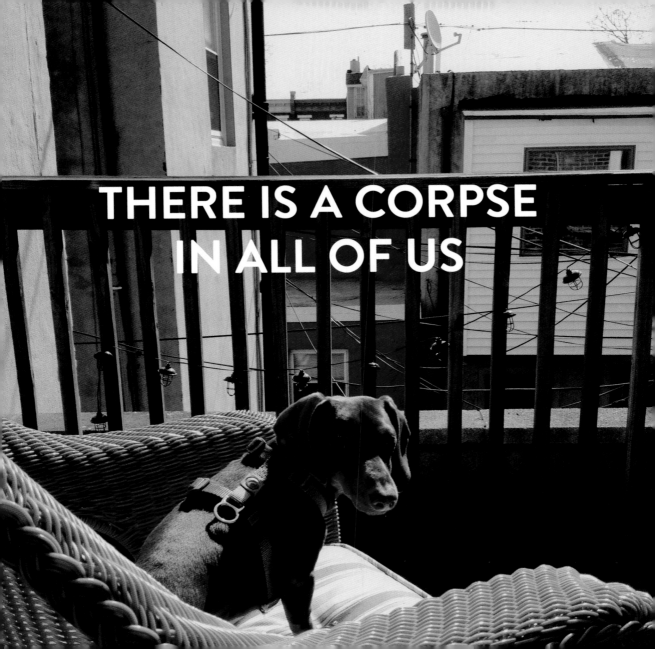

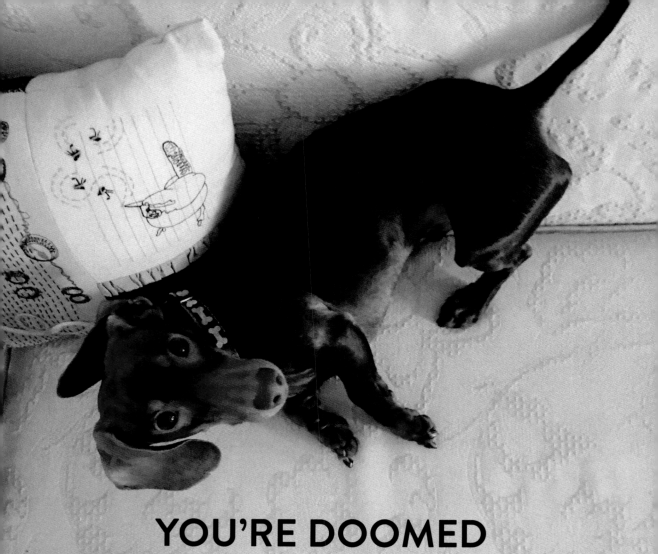

YOU'RE DOOMED

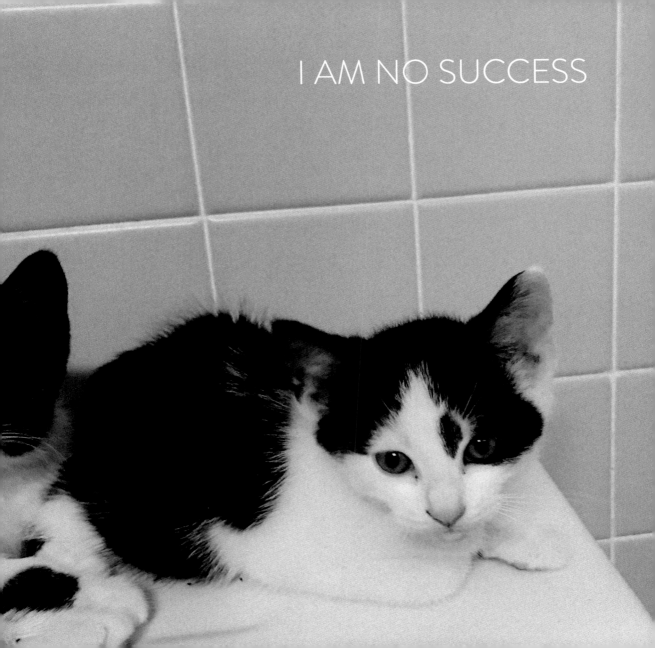

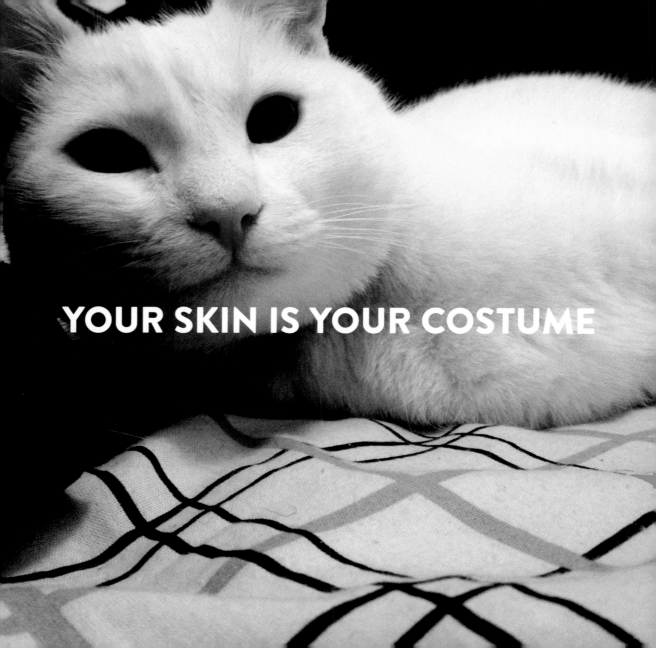

YOUR SKIN IS YOUR COSTUME

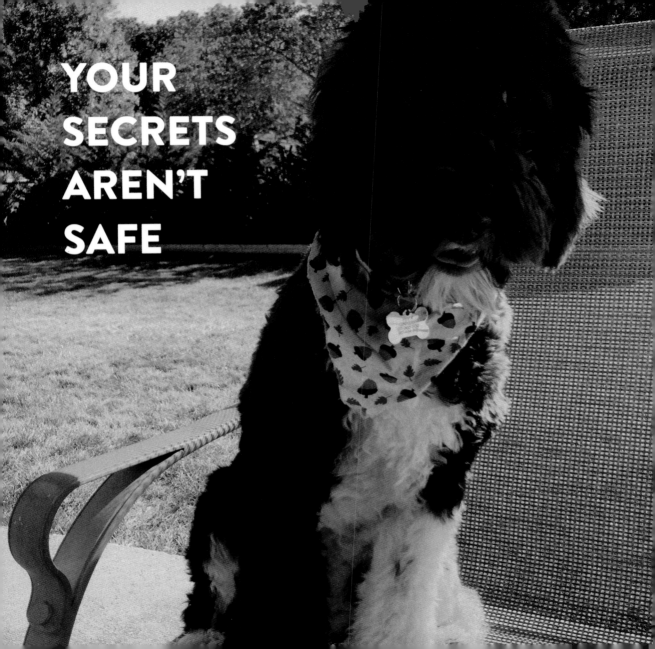

YOUR
SECRETS
AREN'T
SAFE

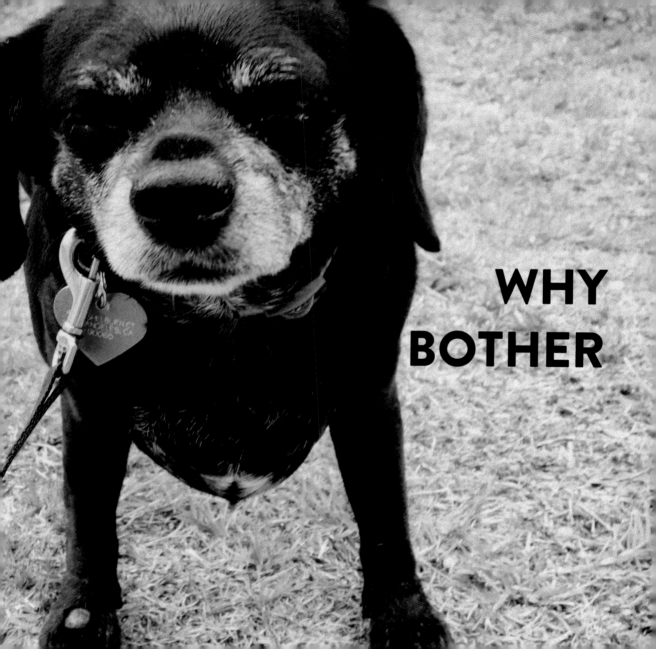

WHY
BOTHER

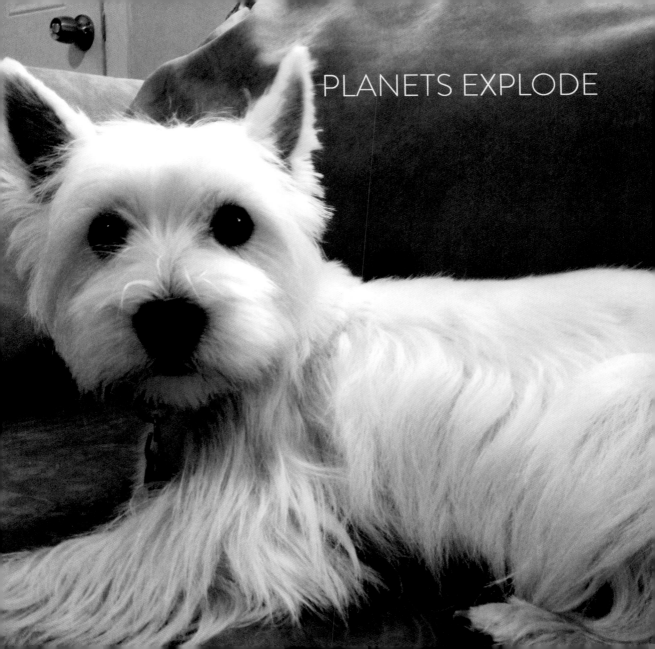

PLANETS EXPLODE

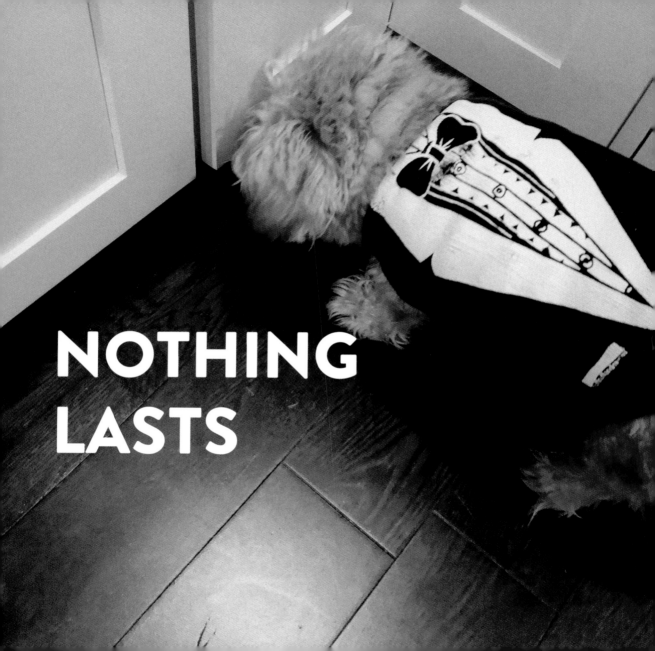

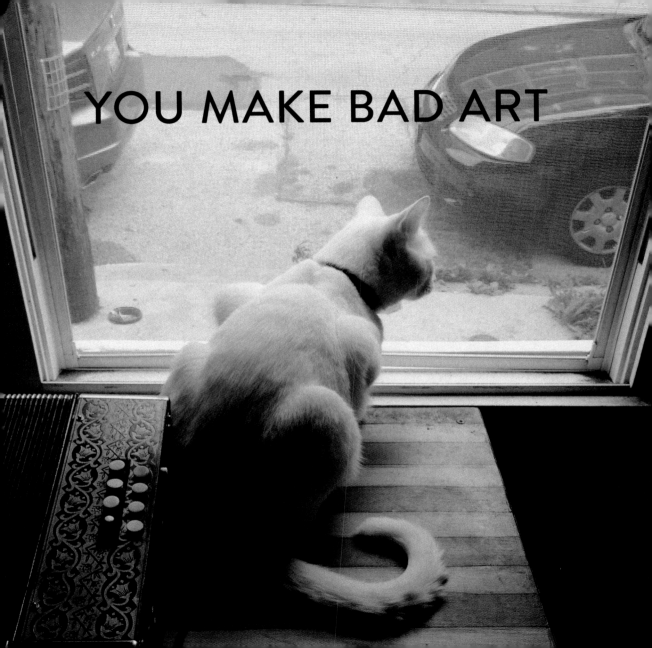

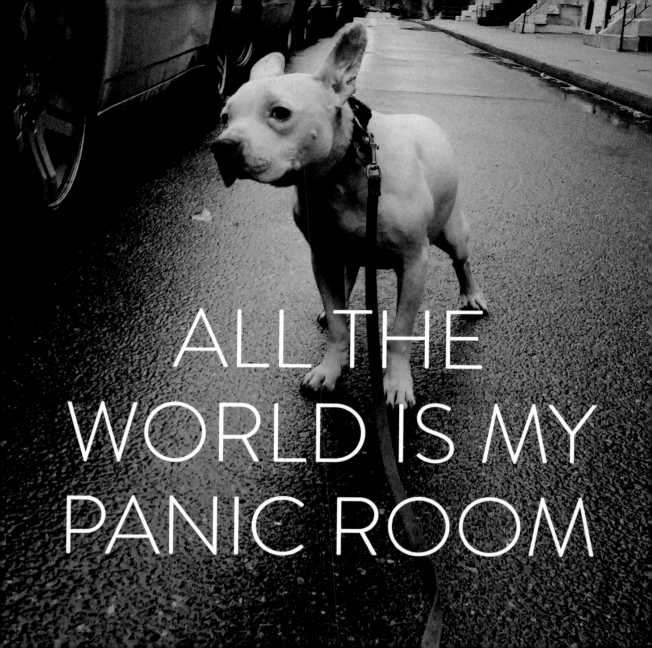

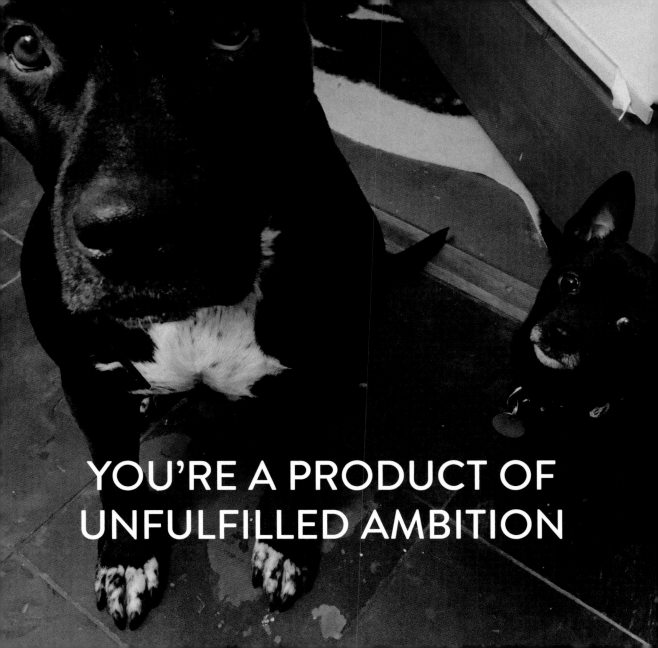

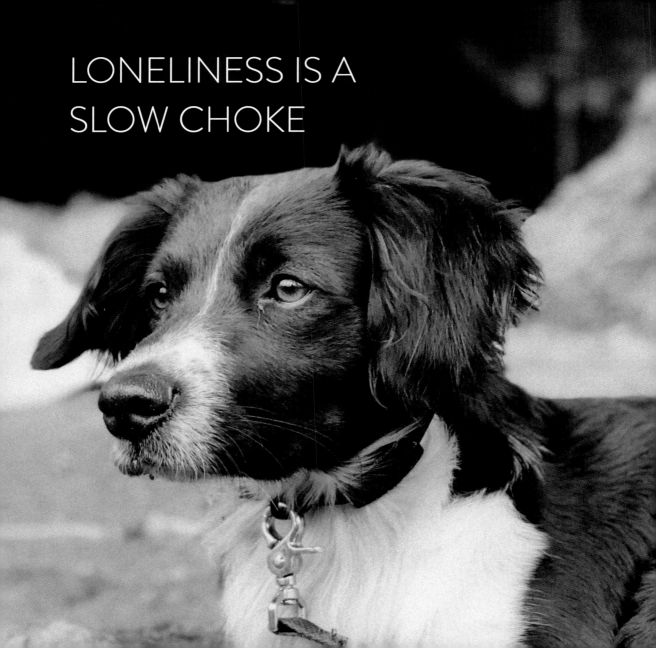

LONELINESS IS A
SLOW CHOKE

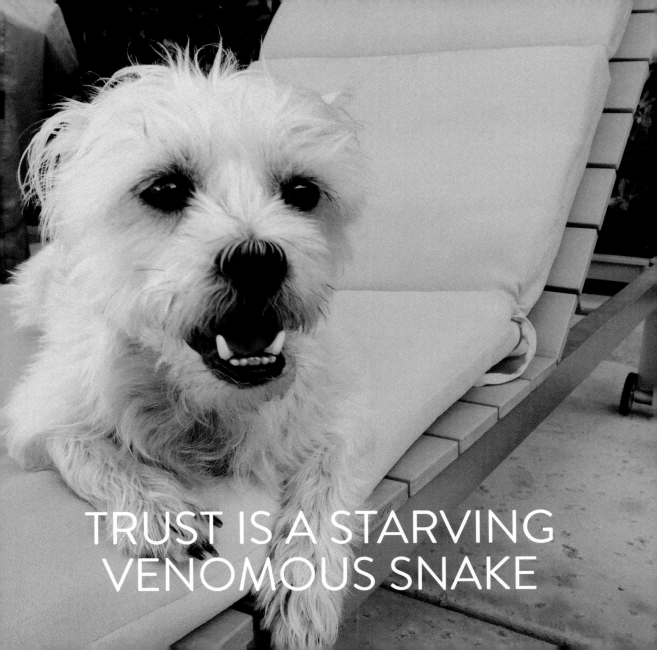

TRUST IS A STARVING
VENOMOUS SNAKE

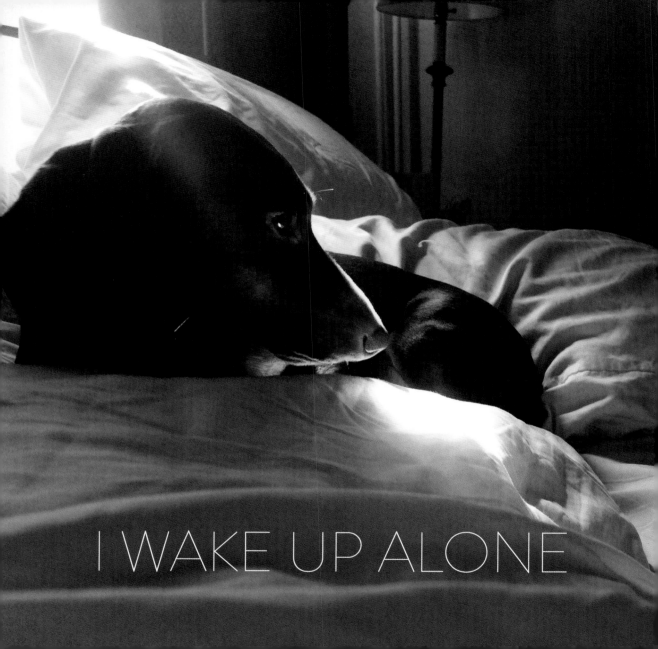

I WAKE UP ALONE

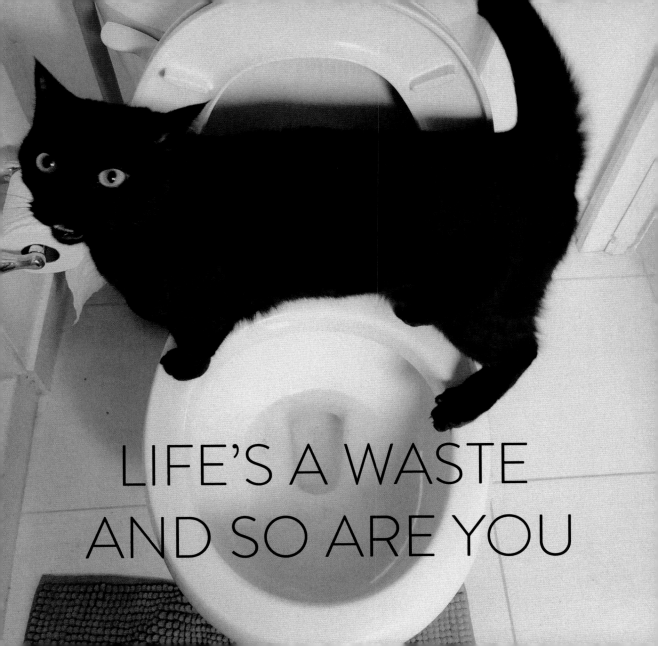

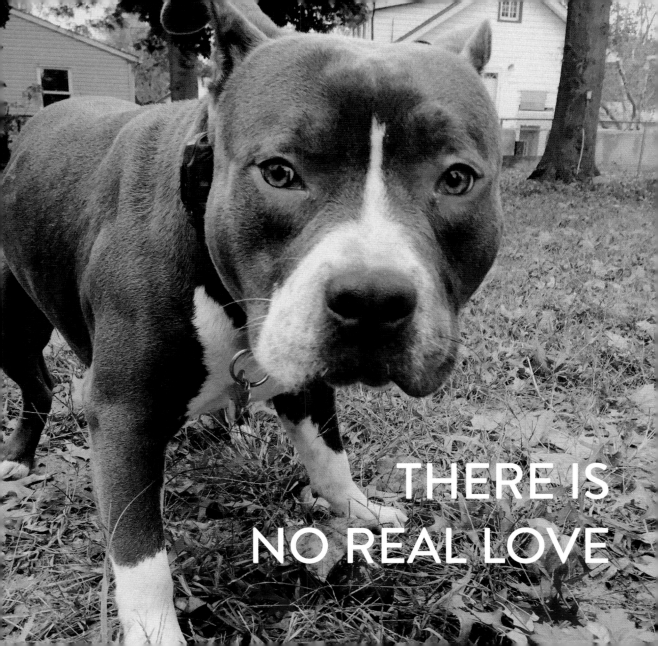

THERE IS
NO REAL LOVE

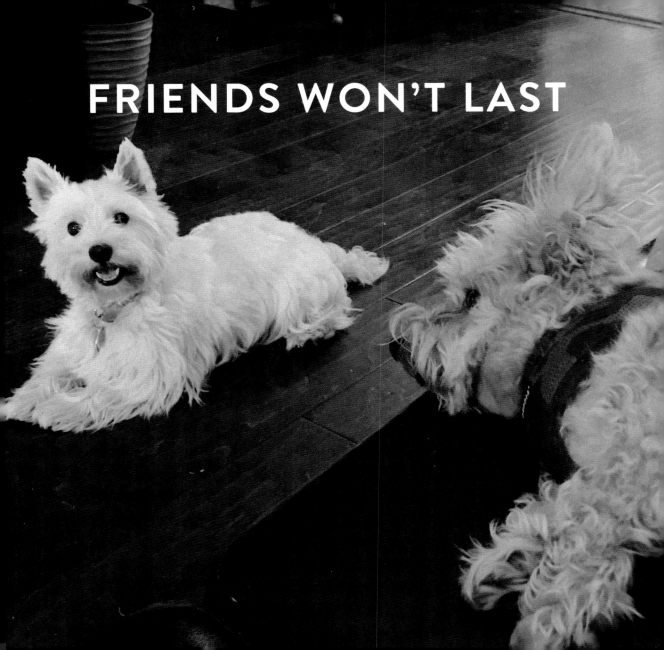

FRIENDS WON'T LAST

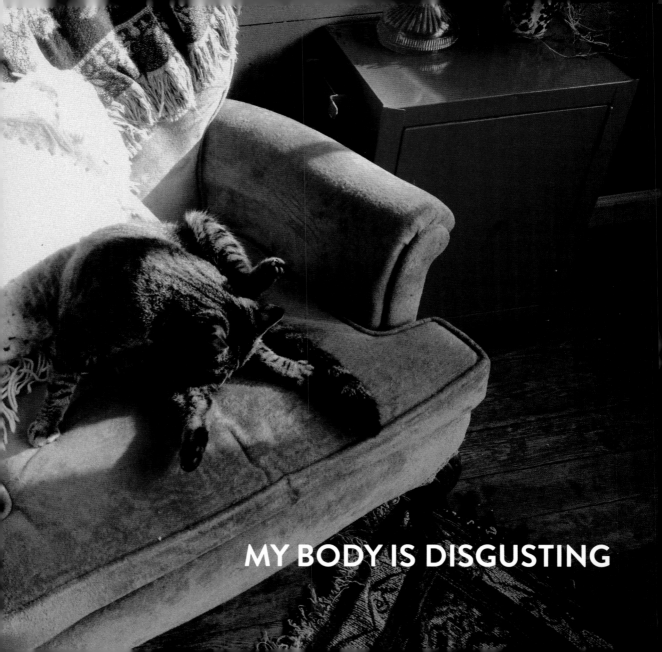

MY BODY IS DISGUSTING

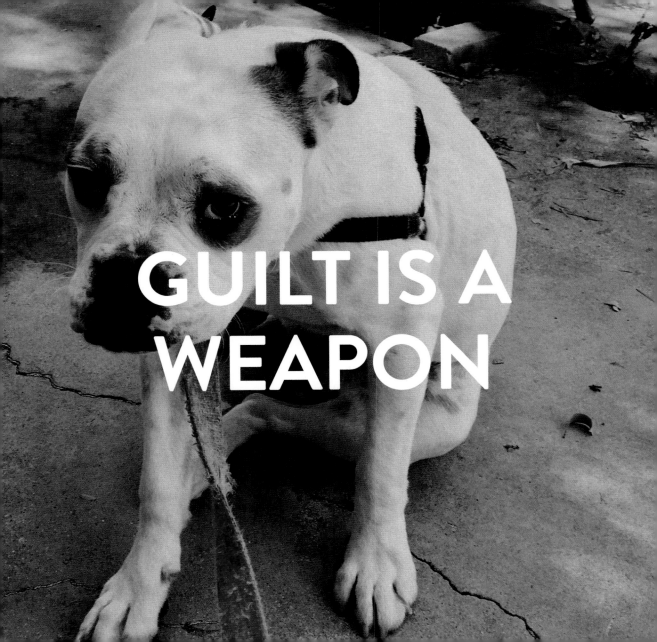

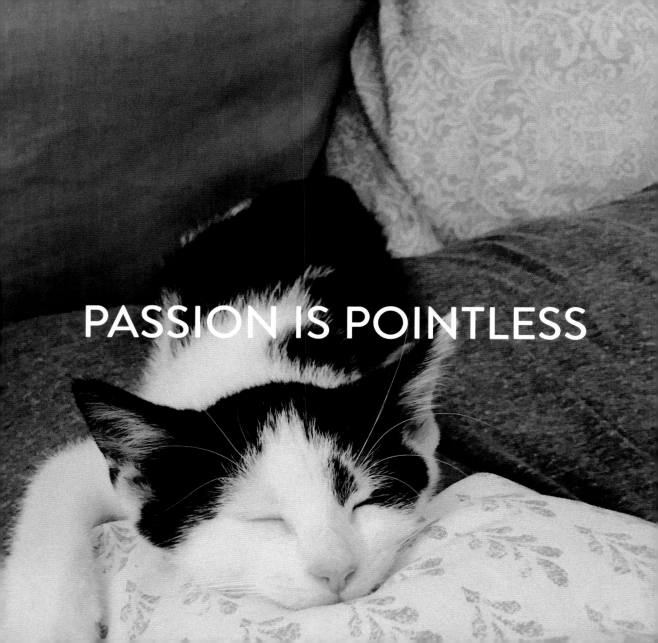

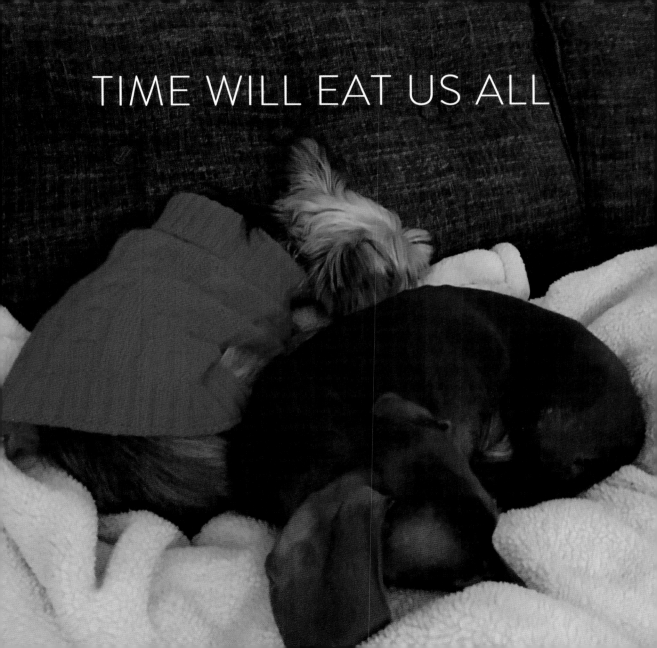

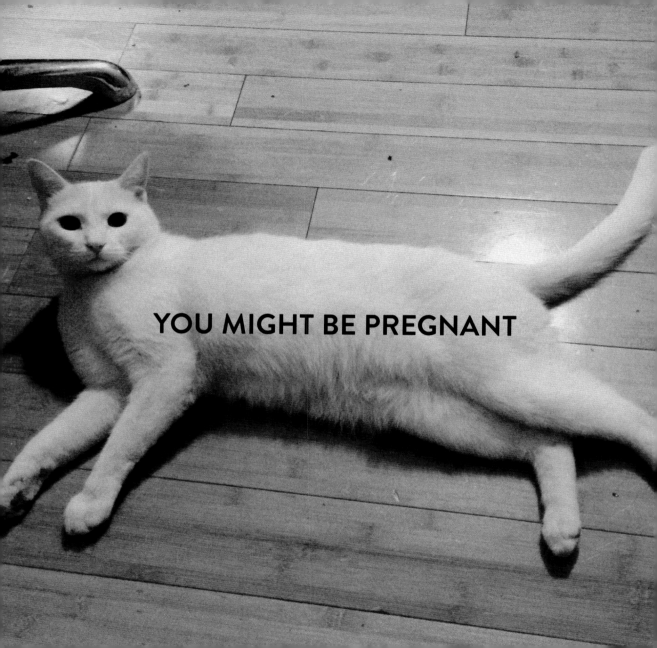

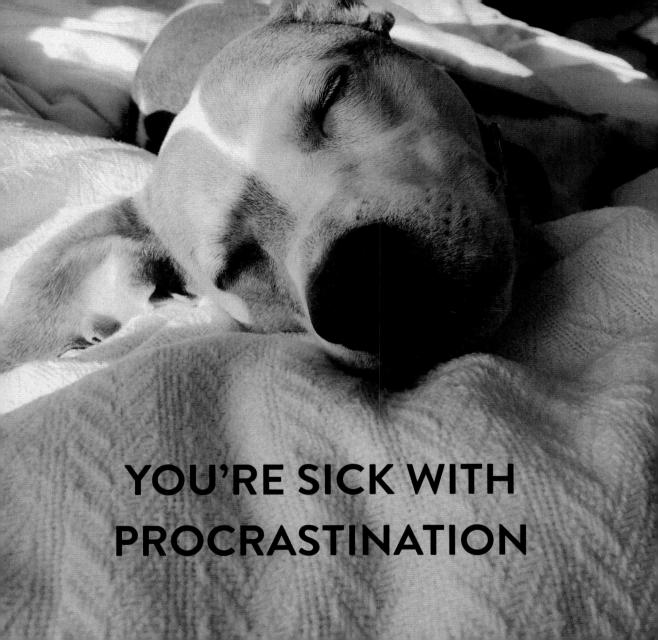

YOU'RE SICK WITH PROCRASTINATION

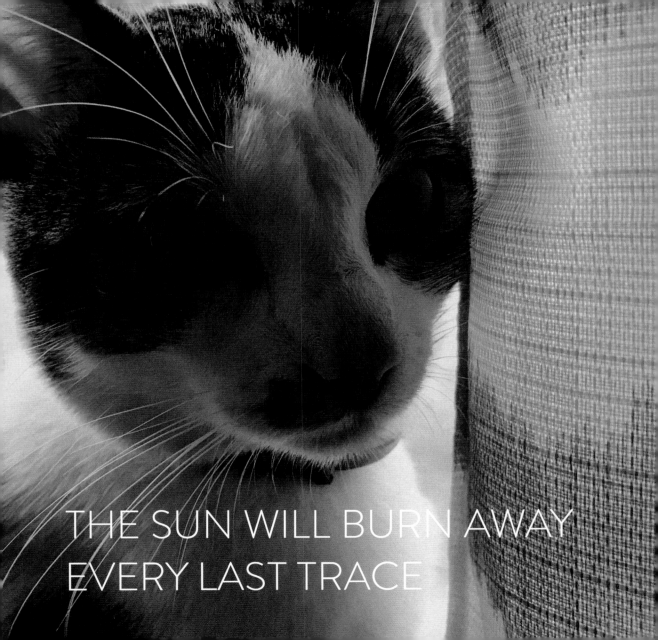

THE SUN WILL BURN AWAY
EVERY LAST TRACE

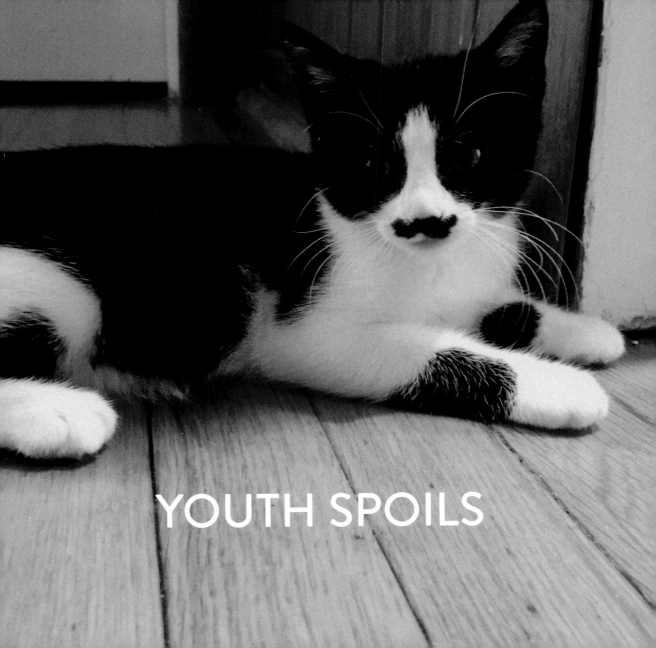

YOUTH SPOILS

YOU'RE A DISAPPOINTMENT TO SOMEONE

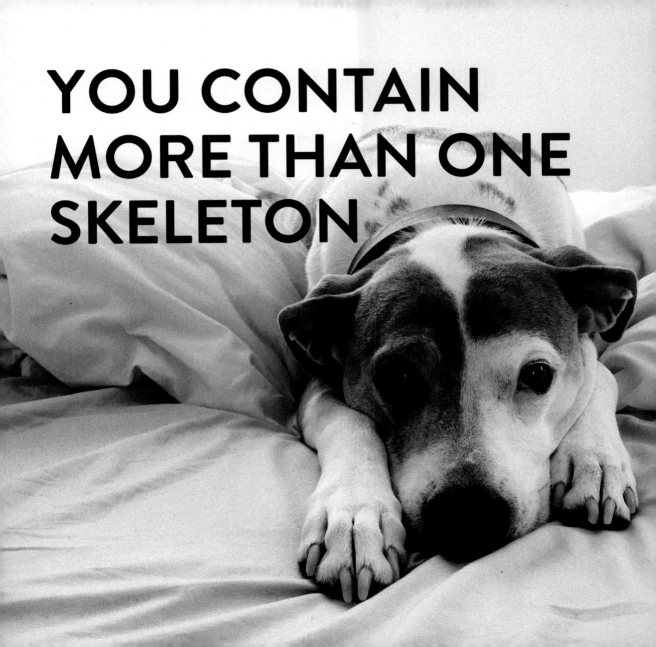

YOU CONTAIN
MORE THAN ONE
SKELETON

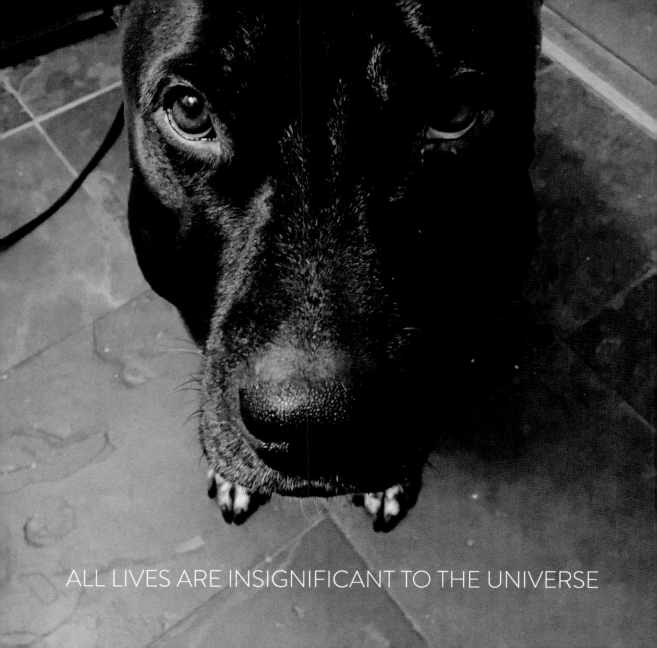

ALL LIVES ARE INSIGNIFICANT TO THE UNIVERSE

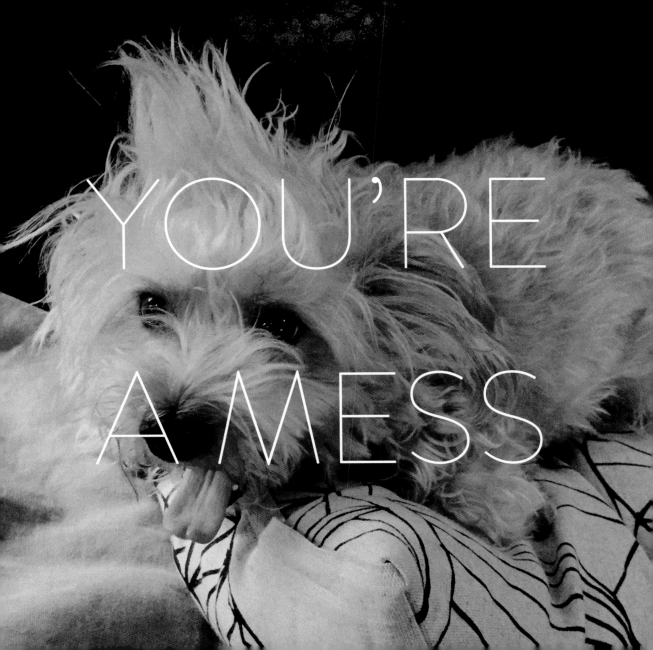

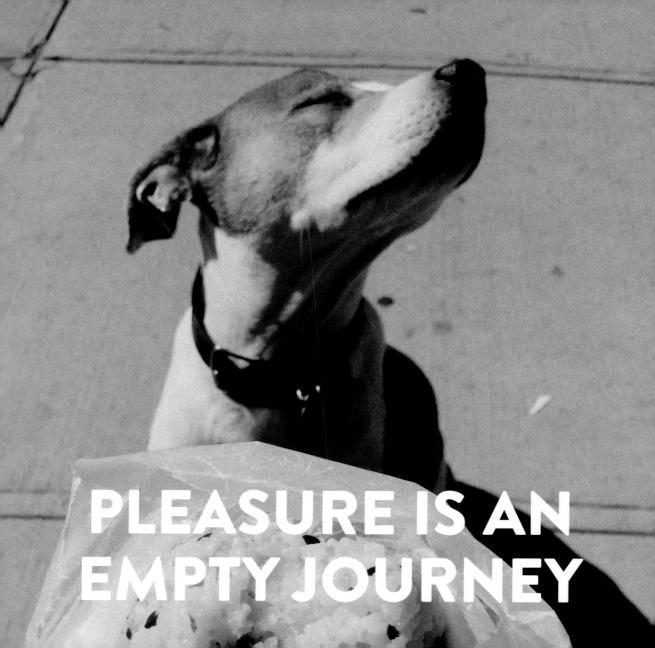

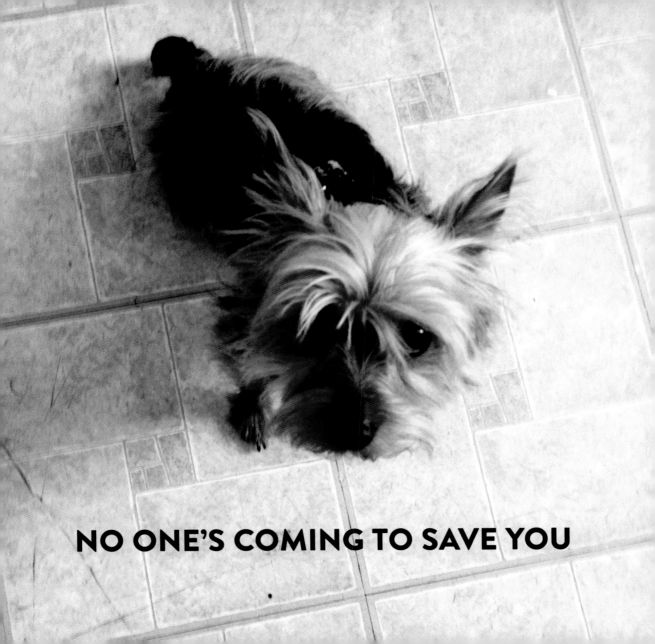

NO ONE'S COMING TO SAVE YOU

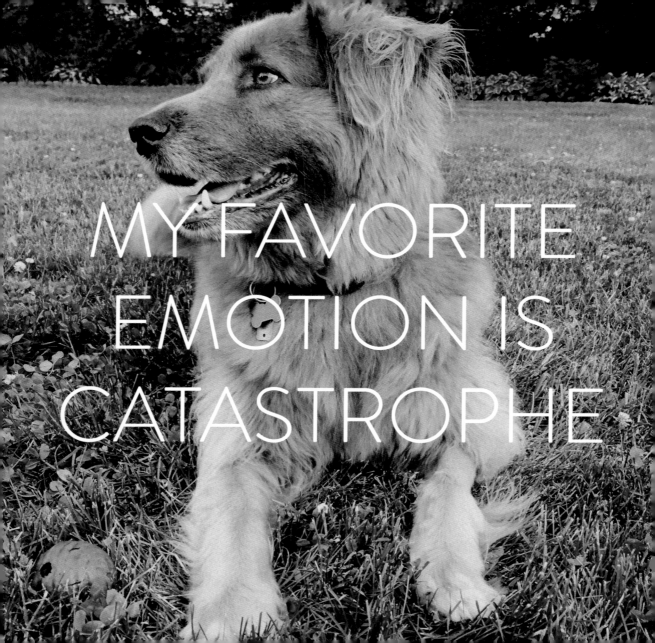

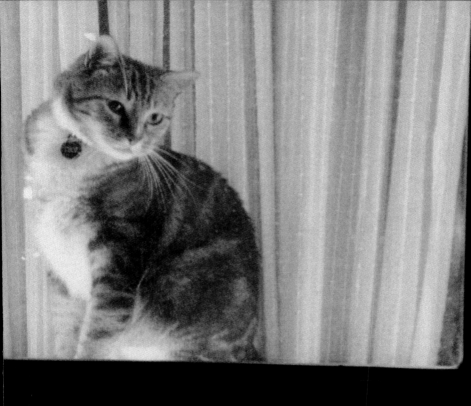

MY ONLY LO
NOST

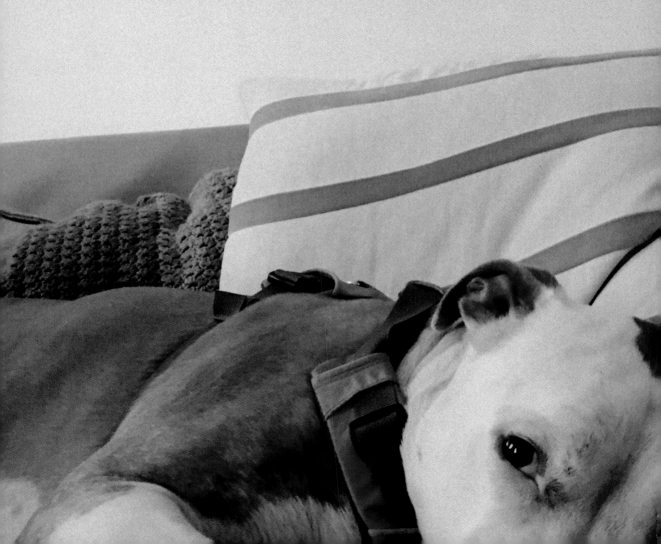

I'M PERMANENTLY IMPERMANENT

EVERY FAILURE IS FOREVER

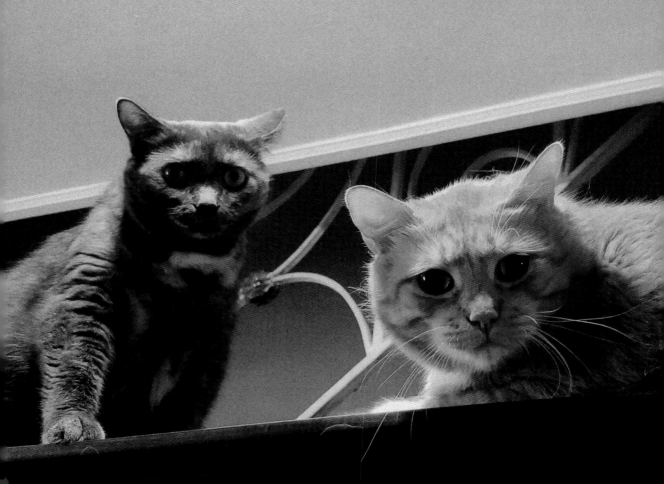

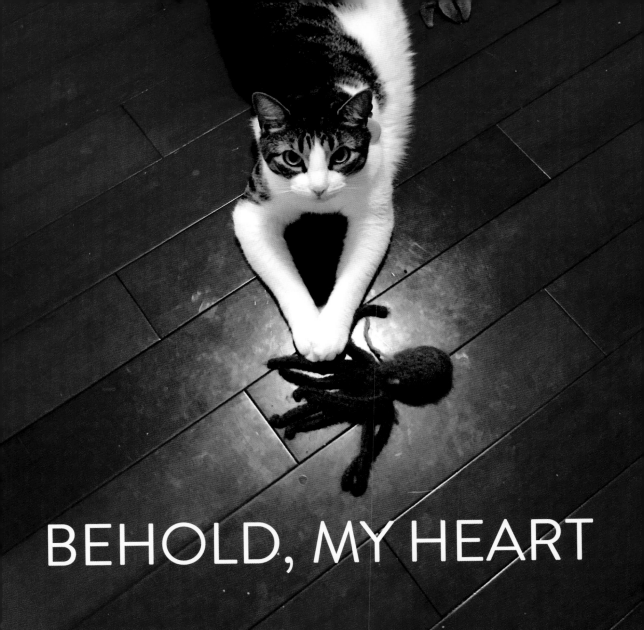

BEHOLD, MY HEART

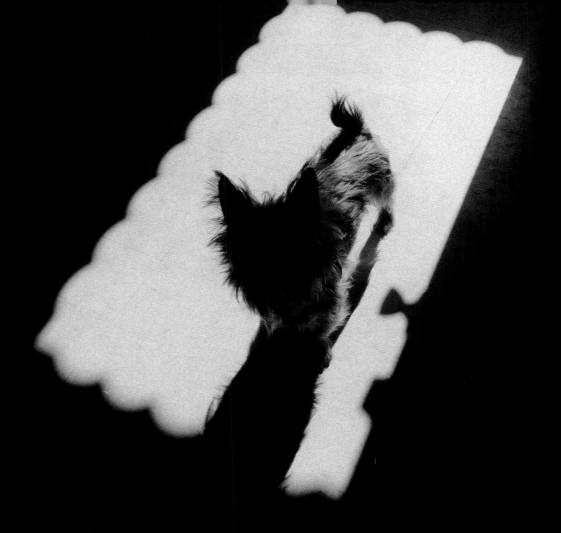

THE WHISPERS IN THE DARK
ARE YOUR OWN

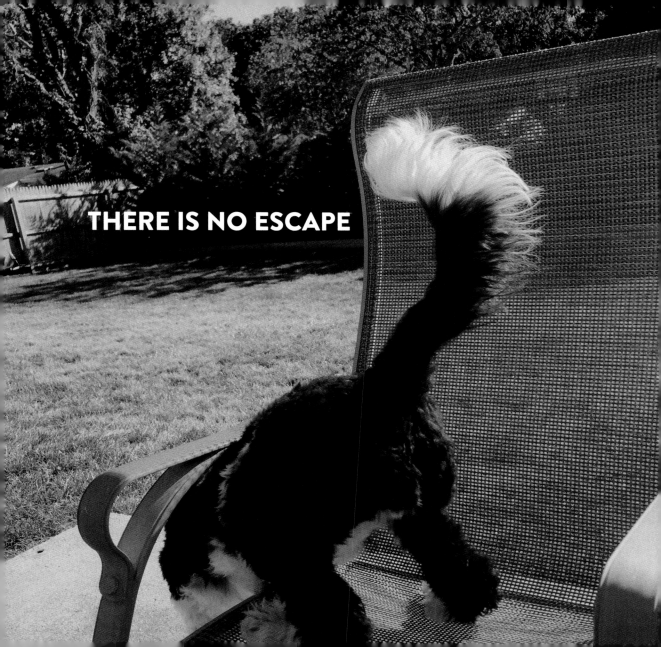

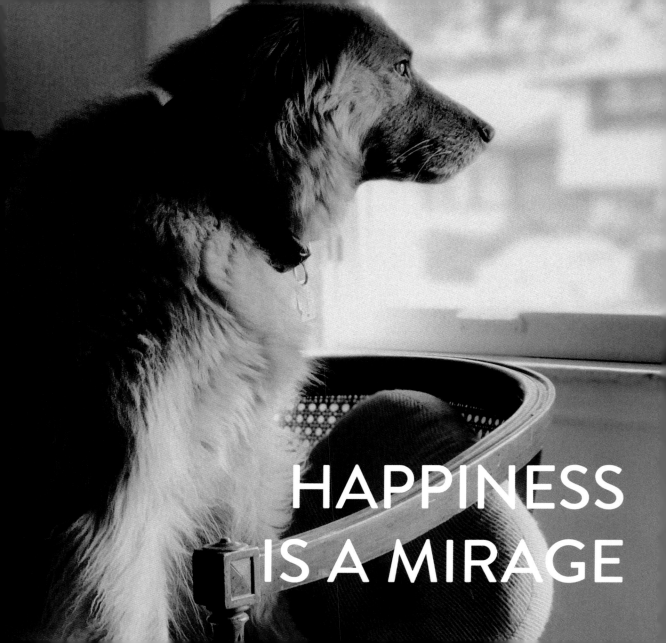

HAPPINESS
IS A MIRAGE

THE CENTER OF THE
EARTH IS CONSTANT
HELLFIRE

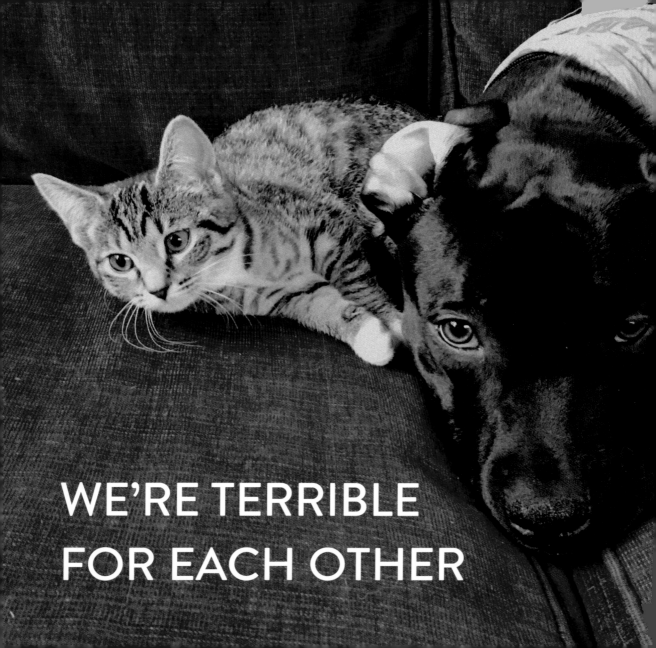

WE'RE TERRIBLE
FOR EACH OTHER

THAT'S NOT AN ITCH THAT'S MORTALITY

LOSS

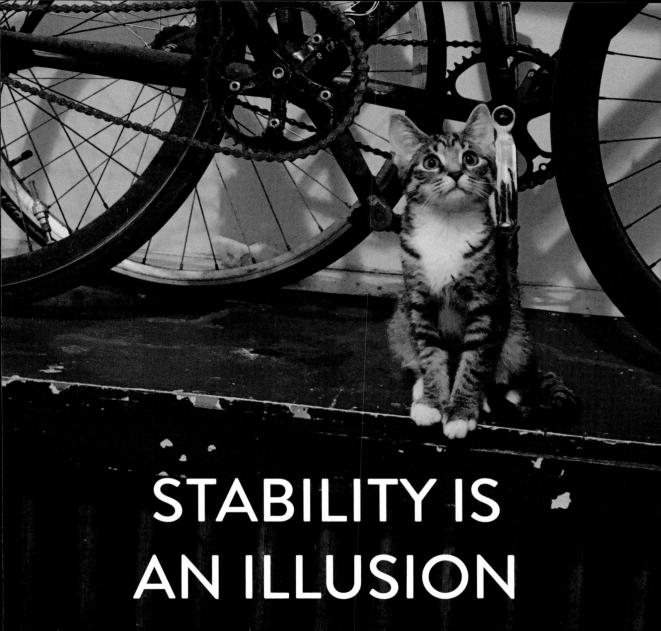

STABILITY IS
AN ILLUSION

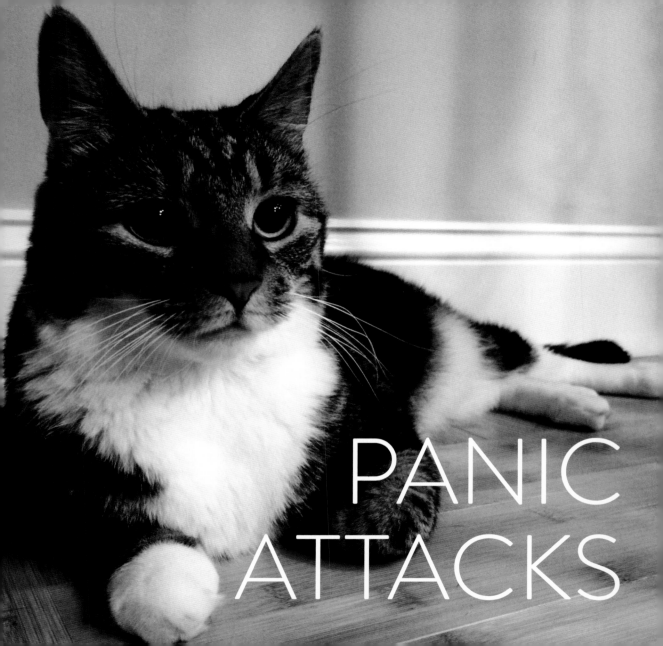

PANIC
ATTACKS

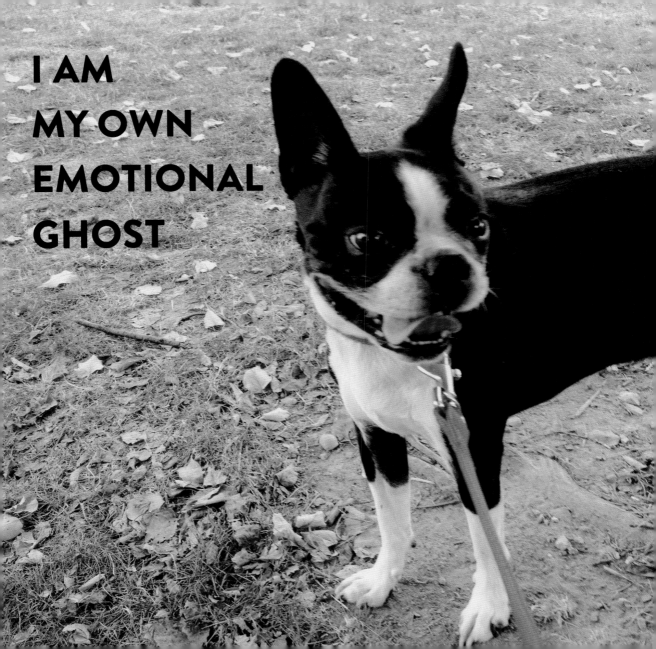

I AM
MY OWN
EMOTIONAL
GHOST

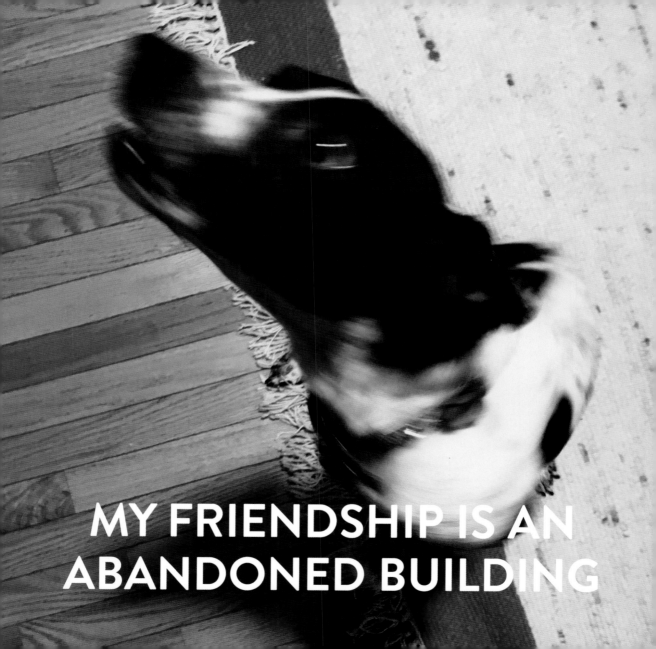

MY FRIENDSHIP IS AN
ABANDONED BUILDING

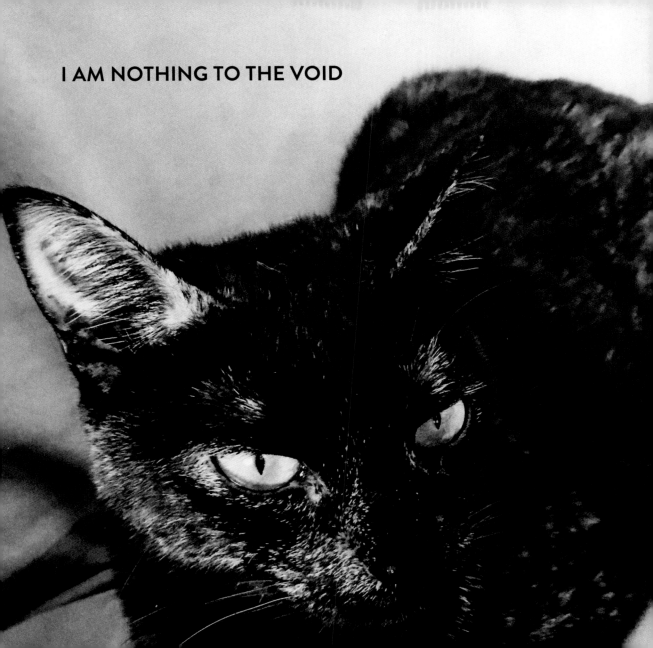

I AM NOTHING TO THE VOID

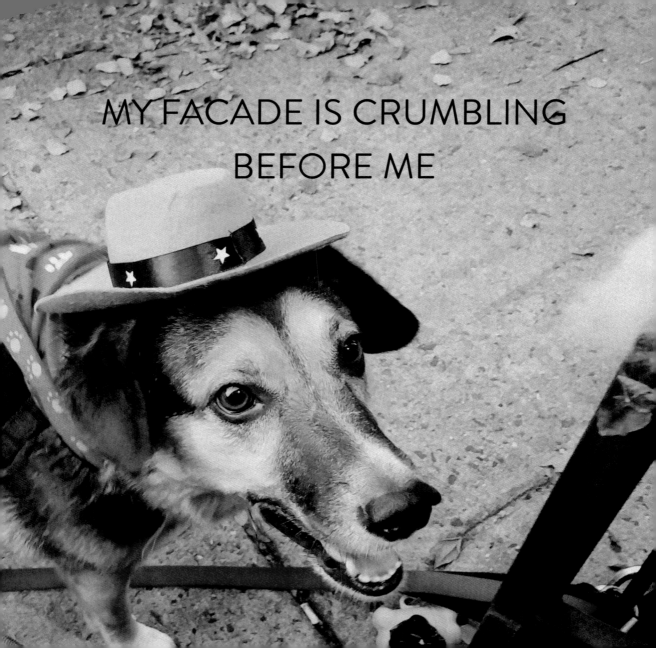

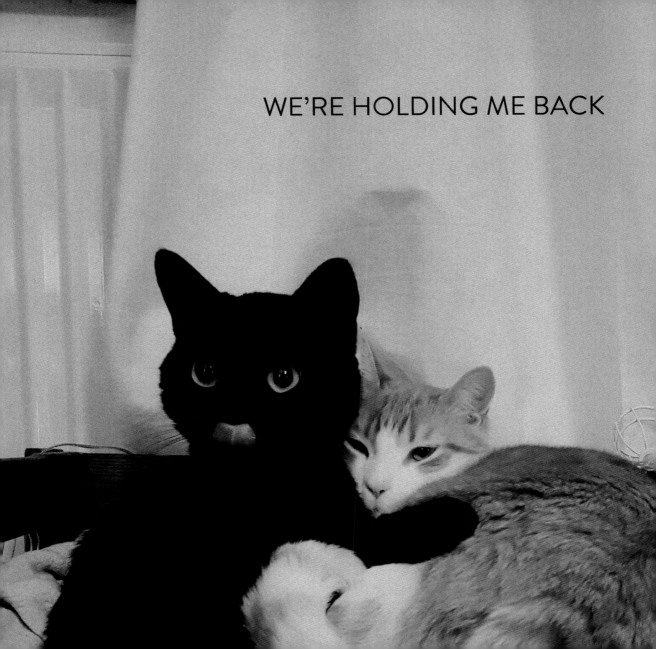

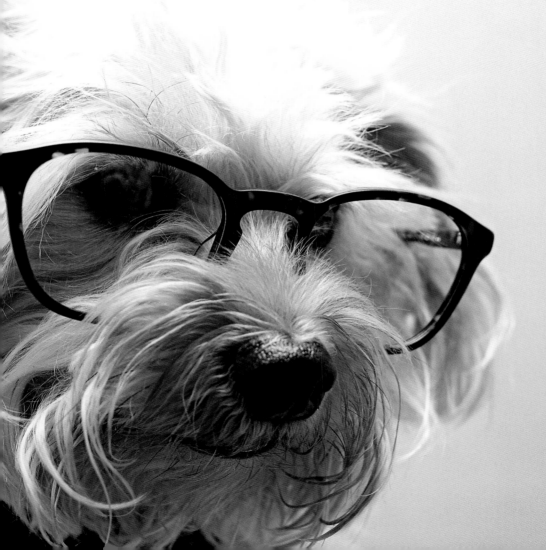

EVERYTHING'S A DEATHTRAP

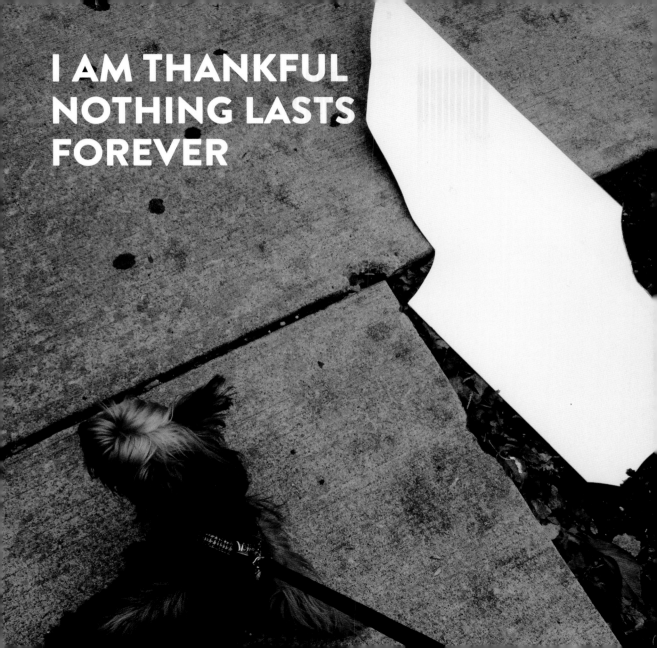

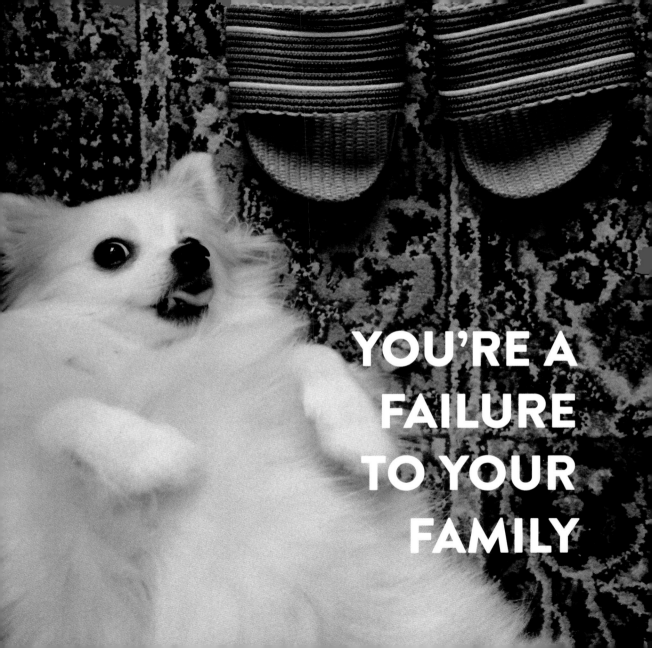

YOU'RE A
FAILURE
TO YOUR
FAMILY

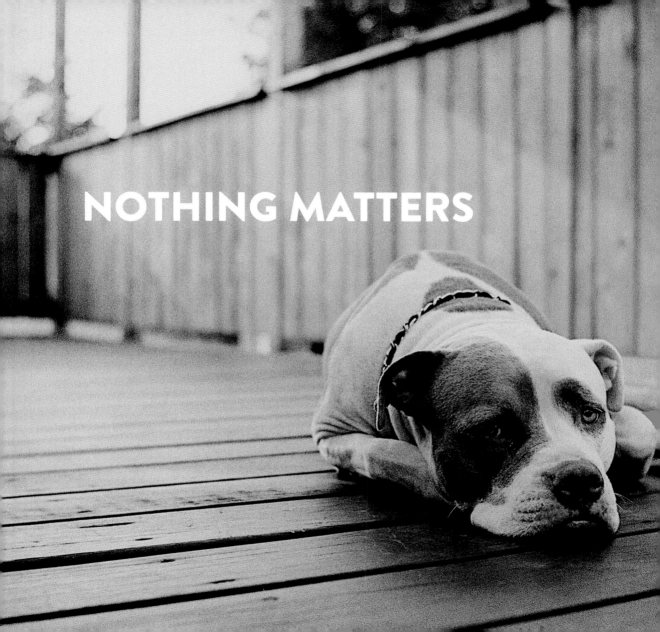

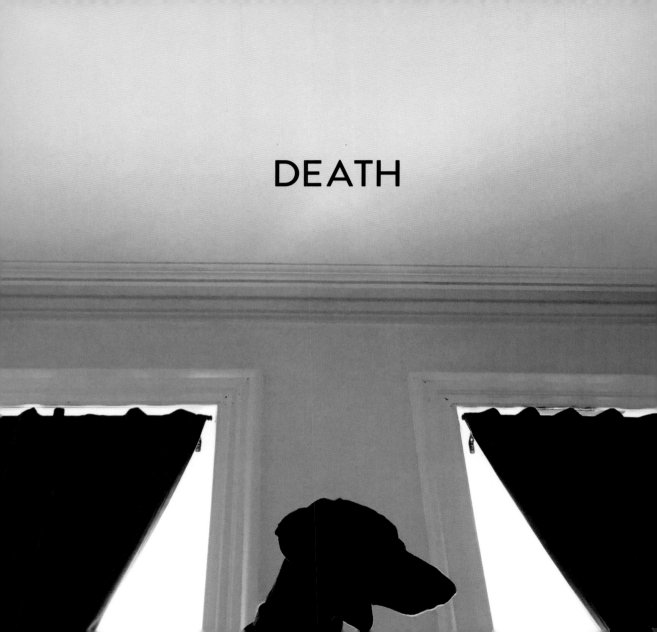

ACKNOWLEDGMENTS

A tempest of thanks to Amy Cianfrone for getting this project to my wonderful editor, Shannon Connors Fabricant, at Running Press Books. For some reason, you all seem to understand this project and I'm not sure if that's a bigger warning sign for you or me. Guess we'll all find out in the end. What an amazing team. You too, Joshua McDonnell—it's gorgeous.

To all of my friends, family, and to the people of Philadelphia whose pets fill these pages and upon whose hearts I mean to cast these shadows: I'll get you all. Your myriad support has made this happen. Thank you, thank you, thank you.

Sarah Ricci, please accept my endless gratitude for your talent and for Zissou. Any other cover would set all color to monochrome. Let's celebrate forever.

To Sara Garside who saw the darkness and the light and remains ever in motion. You believed in this project before and now, look, it's a reality. Thank you for knowing that even nothing is sometimes something. You are missed.

And above all: to Brittany Sweigart. This project would not be possible without you, for innumerable reasons, and everyone needs to know that. If they make it to this page, they will. Thank you for your support, your own shared, sharply written words, and especially in keeping me from going too far into the darkness. Rare is the January flower, but strong it stands against all winds. I love you.

But the real question remains: Why is David Bowie in Target?

ABOUT THE AUTHOR

Alex Beyer is a writer, musician, and dachshund enthusiast. He travels often for his unrelated insurance career, flying 120,000 miles on 85 planes this past year alone. While this is his first book, he has been building his project, *365 Days of Dread*, since 2014. He lives in Philadelphia with his partner, Brittany, and their two terrible dogs.

YOU TURN TO ASHES
IN MY HANDS

THE GRAVE
WILL EAT YOU

YOU'RE UGLY

THE OCEAN
TAKES A LIFE A DAY

THERE IS NO CURE FOR
HAVING NO TALENT

YOU'RE WASTING
YOUR EDUCATION

I AM THE SOURCE
OF EVERY CRISIS
I'VE EVER HAD

YOU DIE IN YOUR OWN ARMS

TRUE LOVE IS A FICTION

YOUR SECRETS
AREN'T SAFE

CAN YOU REALLY
TRUST ME?

FEED YOUR FEARS

AVOIDANCE IS YOU HAUNT
KILLING YOU YOURSELF
I ENJOY NOTHING I AM NOTHING
NO ONE IS YOUR JOB
FAITHFUL IS A TRAP
ALL THE WORLD IS MY PANIC ROOM
FRIENDS WON'T LAST
THIS ISN'T YOU'RE ACTUALLY WORTHLESS
DEPRESSION LIFE'S A WASTE
IT'S FOREVER AND SO ARE YOU
LET ME DISAPPEAR